Fresh Views of the American Revolution Notes and Comments by Paul Foley Paintings by Oscar de Mejo

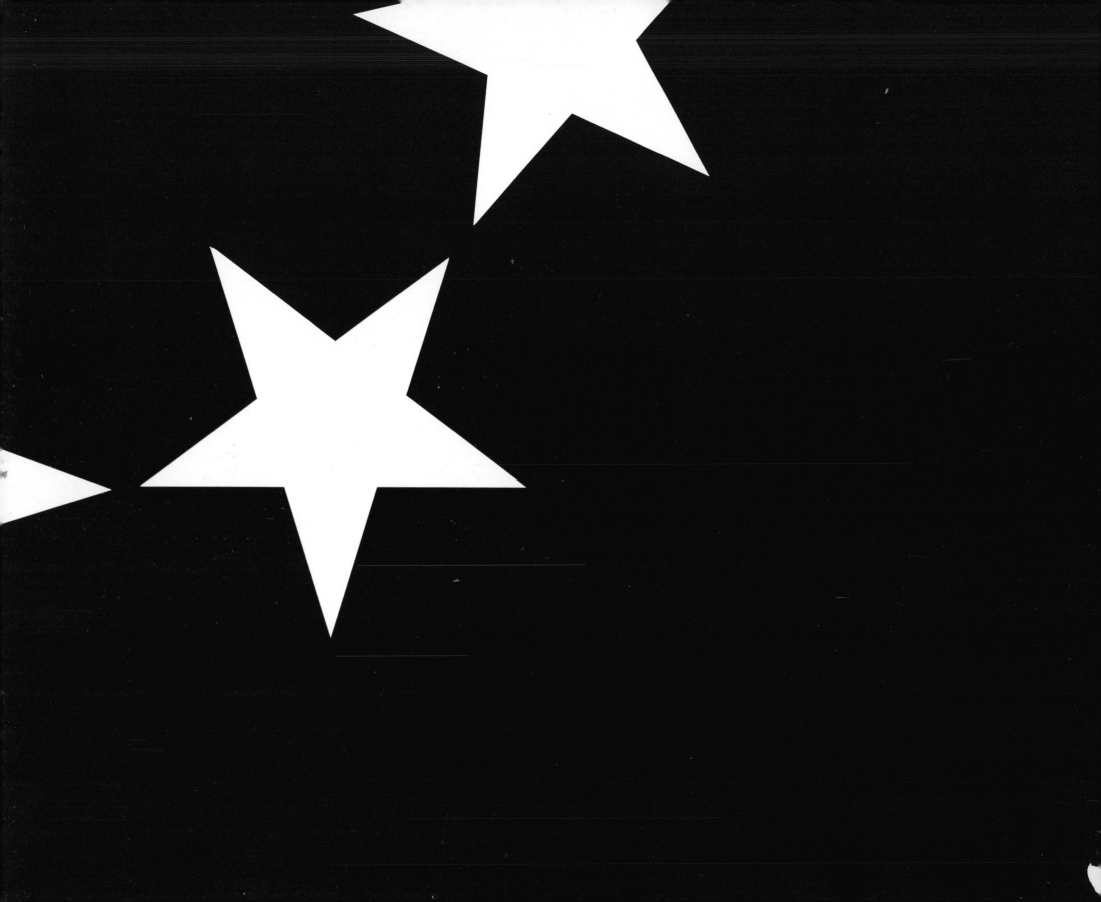

Fresh View

Published 1976 by

Rizzoli International Publications, Inc.
712 Fifth Avenue, New York, N.Y. 10019

Printed in Italy

Library of Congress Catalog Card Number: 75-43455

ISBN 0-8478-0022-9

RIZZOLI
NEW YORK

of the American Revolution

Notes and
Comments
by Paul Foley

Paintings
by Oscar de Mejo

The American Revolution was not a war.

It was something far more potent and awesome: A revolutionary idea of what a free nation is and how a free people should govern themselves.

When it was all over John Adams said it this way:

"What do we mean by the American Revolution?

"Do we mean the American war? The revolution was effected before the war commenced. The revolution was in the minds and hearts of the people.

"Radical change in the principles, opinions, sentiments and affections of the people was the real American Revolution."

The War of Independence was simply the necessary force by which thirteen colonies fought their way free of the British Crown in order to establish and protect a wholly new concept of government.

THE BOSTON TEA PARTY
1774

*The artist, looking back 200 years at a fracas of anger, creates a colorful fable, complete with admiring females and heroic men in a gala, dream-like world—and the tea floats gently by.
(From the Collection of Philip H. Geier, Jr.)*

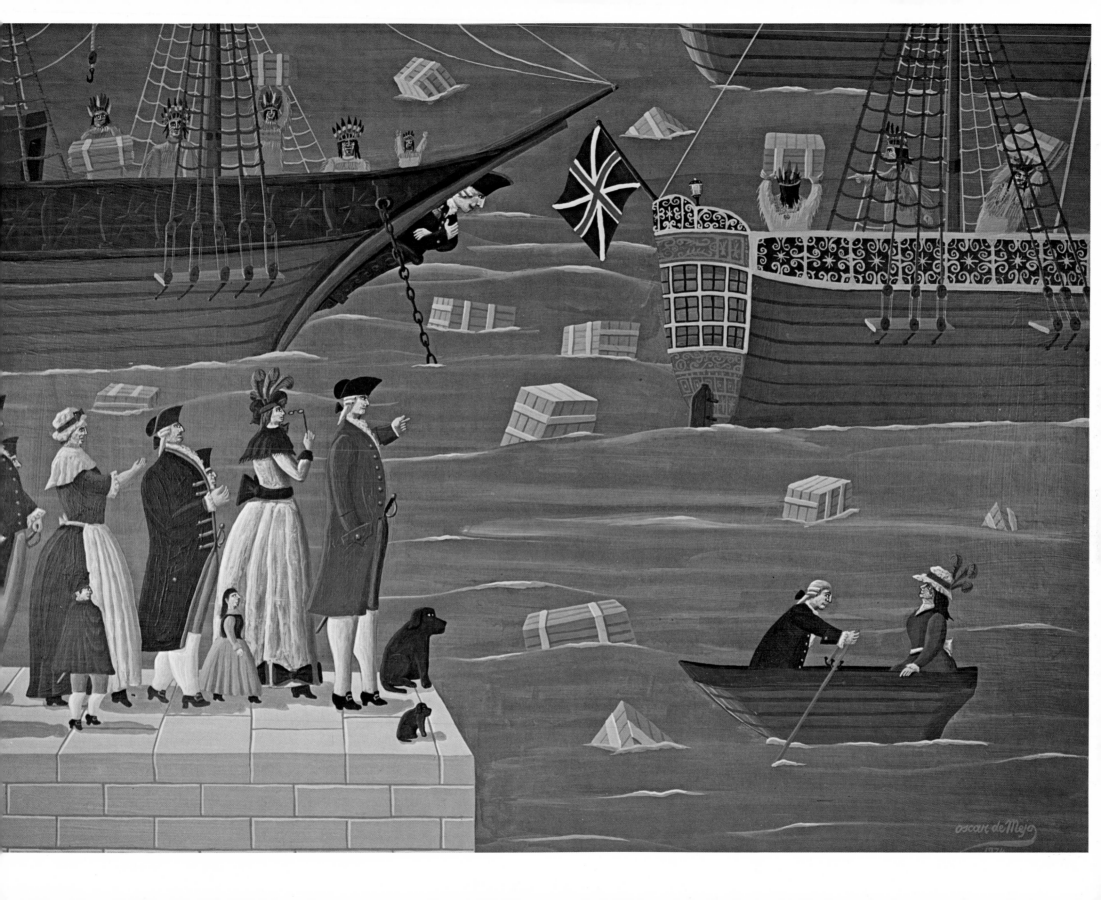

At the heart of this Revolution were these principles:

All men are created equal and are endowed with "unalienable" rights.

To secure these rights governments were instituted among men.

Governments derive their just powers only from the consent of the governed.

When government becomes destructive of these rights, men may change or abolish it.

Men have a right to institute new government to "effect their safety and happiness."

In the long history of man no nation, no system of government had ever before been based on these principles.

It was, indeed, a Revolution—which went so far as to legalize revolution itself.

Americans independence was a long time coming.

Descendants of the first settlers in Colonial America lived and died on this continent at least as many years before the Revolution as we Americans have lived here since the Declaration of Independence.

Spanish colonists settled St. Augustine as early as 1565. The British colony at Jamestown, Virginia, dates from 1608. The Mayflower landed its Pilgrim settlers in Massachusetts 150 years before the first scuffles of revolt were heard in the streets of Boston.

By 1750, there were about three million Colonials living in the thirteen colonies which stretched nearly 1,500 miles along the Atlantic Coast from the Maine district of Massachusetts to southern Georgia. Of the pre-war Colonial population about 400,000 were blacks, most of them slaves in the agricultural South.

Surely these Colonials—many of them second or third generation on this soil—thought of themselves as Americans.

The Prelude: 1754

At least two things seem true of the world's major conflicts: Their earliest causes are seldom seen clearly. When the struggle is over history usually regards the conflict as having been inevitable.

The American Revolution is no exception.

There can be little doubt, however, that among the immediate causes of the American War of Independence was the long and costly British "victory" in the Seven Years War in Europe and its American phase, the French and Indian War.

In 1754, the French, with their Indian allies as guerrilla fighters, brought the conflict to the American Colonies. One of their first moves was to destroy a British fortification at what is now Pittsburgh. Here they erected Fort Duquesne. The British command, largely with Colonial troops including a unit of the Virginia militia under command of a 21-year old horseman named George Washington, tried to unseat the French and were soundly beaten.

In 1755, Britain threw in the first team. Major-General Edward Braddock of the Coldstream Guards, commanding a much superior force, learned early that the rivers and woods and Indians of a wild and rugged land do not yield easily to professional tactics imported from Europe. Braddock was ambushed and his Guards cut to pieces by the French and their "savage Indians."

The reaction from London was not unlike the reaction 200 years later when bad news reached the Pentagon from the jungles of Viet Nam: "Pour in more troops, more weapons, more generals."

The result, too, was much the same. Crack British troops led by proud officers suffered and died in the strange mountains and deep forests of a rugged land. American colonial troops were part of it all and saw the legendary superiority of British arms strain and struggle and sometimes crumble.

Quebec and Montreal surrendered in 1760. The Treaty of Paris ended the long struggle on both fronts in 1763. Britain had won on two continents. But the price had been very high.

In less than two decades Britain's public debt had nearly tripled. The British treasury was dry, but the demands of the empire were great: A full strength army at home to insure the hard won peace; 8,000 regulars in the American colonies; troops in Canada with its large and restless French population. And on the high seas a British fleet on both sides of the Atlantic and deep into the West Indies.

Under these pressures the prosperous American colonies seemed a logical and rich source of funds. To the Chancellor of the Exchequer the Crown had a clear right and a visible need to raise money by direct taxes in the colonies—not *on* the colonies, but *in* the colonies. Thus were born the Sugar Tax, the Quartering Act and the highly volatile, short-lived Stamp Act.

It was the Stamp Act which did it as far as the colonists were concerned. They flatly refused to pay. The colonies instituted a tight boycott on English goods and it was felt in London. It hurt so seriously, in fact, that the Stamp Act was quickly repealed. A series of "duties" on British imports, including the hated Tea Tax, was substituted. But the Americans had tasted blood and reacted promptly with a new boycott and in more cases than one threw the "duchied goods" overboard in the harbors.

It was this first act of direct taxation on the goods and actions of their daily lives which sowed a bitter seed among the colonials, not the taxes themselves, but the assumption of the right to tax people who had no representation in the British government. A people, indeed, who were Americans. The stiffening British rule was chafing badly.

And now there were red-coated British Regulars in Boston, in New York, in Philadelphia. To a great many local citizens they were clearly "foreign troops" and to be scorned.

The Boston Massacre

By 1770, Britain's best soldiers were being kept close to home, alert to every move of the French. The powerful British fleet, too, was dispersed in the service of the empire.

Most British forces in the American colonies were bottom-of-the-barrel soldiers, poorly paid, badly quartered, often with hostile landlords. During off-duty hours those in the cities scrounged for work as handymen to get a little cash in hand.

Things were not all that serene in Boston in the Winter of 1770. Jobs were not plentiful, times were unsettled and tempers short. Hardly a week went by without some kind of scuffle between the townsmen and the bedeviled British soldiers.

March 5, 1770, was the kind of damp, cold late-winter Boston day that chills the bones. In late afternoon a shivering Redcoat was poking around near Custom Square looking for a job. He was shoved around a bit and scornfully told to clean out a privy. One thing led to another and blows were struck.

As the drab day slipped into a bitter-cold evening the scuffles spread. At about eight o'clock a group of hotheads knotted together in front of the Custom House to jeer and taunt a British officer. The jaw-boning, probably fired by a good deal of rum, led to punching and shoving. A British sentry was knocked down by a couple of the loudest locals. A crowd formed, stones and chunks of ice were thrown and the sentry yelled for help. Captain Thomas Preston with eight of His Majesty's soldiers came on the scene to restore order.

There are at least two versions of what happened next. One version has the crowd jeering and taunting the troops, crying: "Fire, you lobsterbacks. Go ahead, Fire!"

The second version has Captain Preston shouting to be heard over the melee, urging his troops to "Hold your fire! Hold fire!"

Somebody in the mob threw a barrel stave which hit a soldier named Hugh Montgomery. Through the hubbub Montgomery heard the word "Fire"—so he fired and a black man in the crowd crumpled into the slush of the street.

The mob surged forward. His Majesty's troops panicked and opened fire. When the smoke cleared and the shouting stopped three civilians were dead on the spot. Two more died later and seven others were wounded.

Among the dead was Crispus Attucks the black man who was the first to fall, "killed instantly by two balls entering his breast goring the right lobe of the lungs and a great part of the liver most horrible." Attucks, born in Framingham, Massachusetts, was said to be in Boston trying to ship out to North Carolina.

The whole bloody affair was a case of nerves rubbed raw, of frustrations and anger exploding in an outburst that was over in less than an hour. But it was an enormous and costly blunder. British troops, hailed as the best disciplined, most respected army in the world had lost their heads and been goaded into point-blank killing of unarmed civilians.

This public act of panic was all Sam Adams needed. Adams, surely one of the most ardent propagandists any cause ever had, knew exactly what to do with this explosive scuffle.

It was Sam Adams who caused his friend Paul Revere to make an "eye witness" engraving of the event showing British troops in full dress firing a carefully aimed volley into a group of peaceful Bostonians.

The engraved illustration with a highly charged account of "The Bloody Massacre Perpetrated in King Street, Boston, by a Part of the 29th Regiment" was published in the Boston Gazette on March 12.

Thus an hour of street rioting was transformed into "The Boston Massacre" and the account of it circulated far and wide in the Colonies and as far away as London.

It was effective. There seemed little doubt among the more militant patriots that the die had been cast. His Majesty's troops had killed Colonial civilians.

THE BOSTON MASSACRE
MARCH, 1770

"Primitive" art is simple, human storytelling. Proper Bostonians throw rocks at proper Soldiers; Soldiers react, people scramble, drop glasses and pipes. Women lament. It is all magically clear, but these guns don't seem to kill, they go "Bang."

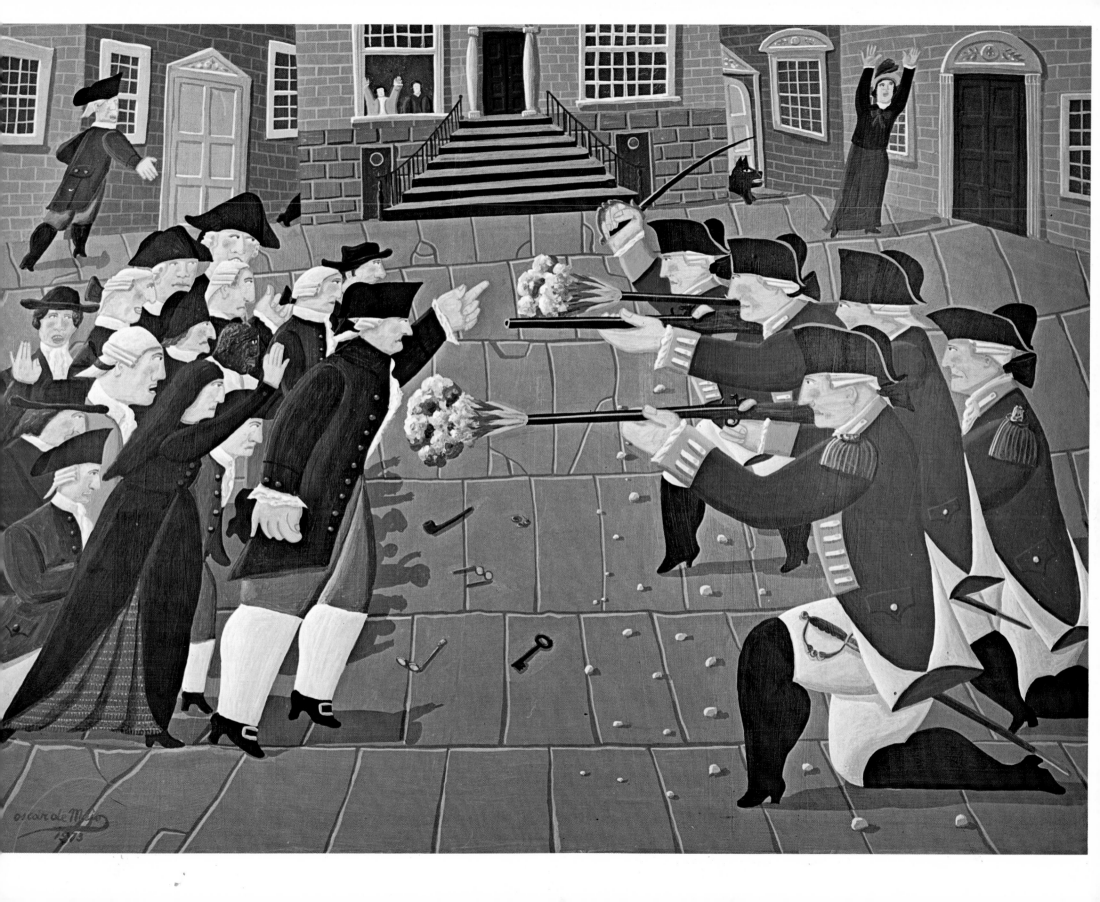

But it was to be five years—five years of tumult as well as serious debate, soul searching and formal declarations—before "the shots heard 'round the world" were fired at Lexington and Concord.

The "facts" of the Boston Massacre have remained vividly alive in the telling of American history. It is odd that one of the singular aspects of the event is all but forgotten: The fact that Captain Preston and the British soldiers involved were brought to trial by a jury of Massachusetts colonials who either acquitted them altogether or punished them only moderately.

Captain Preston went to trial first before the Massachusetts General Court on October 24, 1770. After a six day trial he was acquitted by the jury on the simple ground that no evidence existed that he had ordered the troops to fire.

In November, 1770, the eight enlisted men were tried. Six of them were found innocent, a decision reached by the jury after several days of testimony.

The other two soldiers, Matthew Kilroy and Hugh Montgomery, specifically charged with murder in the deaths of Attucks and Gray, were, instead, found guilty of manslaughter and let off with the comparatively light sentence: "To be branded on the left thumb."

All of the accused were represented by counsel of their choice—John Adams, that staunch patriot and serious architect of American freedom who was to become the second President of the United States.

Adams presented a defense devoid of passion or flight of oratory. It was a simple, tightly reasoned statement of the right of those pressed and harassed by an angry mob to defend themselves. He closed with a simple statement:

"Facts are stubborn things. Whatever may be our wishes, our inclinations or the dictates of our passions, they cannot alter the state of facts and evidence. We must try causes in the tribunal of justice, by the law of the land."

The Last Petition

Any lingering hope of reconciliation between the American Colonies and the British of George III vanished when the resolutions of the First Continental Congress of 1774 were ignored by London.

This First Congress was attended by delegates from twelve of the Colonies, only Georgia was missing. It convened in the early Summer of 1774 in Carpenters Hall, Philadelphia. In October the Congress issued a "Declaration of Resolves." It was a strongly worded attack on the Coercive Acts and specifically condemned the system of direct taxation on the Colonies. But it stopped far short of a demand for independence. In fact its only threatened action against Britain was an economic boycott.

The last act of the First Continental Congress was a sincere, respectful petition to the King urging him to remedy the offenses against the people of the American colonies.

On this note the Congress adjourned, agreeing to meet again on May 10, 1775, unless they had received relief of their grievances.

The Glorious Victory Mistakenly Called The Battle of Bunker Hill

In early June, 1775, His Majesty's ship Cerberus arrived in Boston harbor from London with three Generals whose reputations would never again be quite so high: Sir William Howe, Sir Henry Clinton and Sir John Burgoyne. They were warmly welcomed by General Thomas Gage.

While the three arriving heroes settled in, enjoyed the gentle Summer weather and put the rigors of the crossing behind them, the Colonials under Colonel William Prescott concentrated on tightening the siege

THE BATTLE
ON BREED'S HILL
JUNE, 1775

A combination of meticulous accuracy of weapons, uniforms and detail in a world made clear and simple—Breed's Hill becomes an ancient morality play: Arrogant power meets modest, determined virtue. Virtue wins the day.

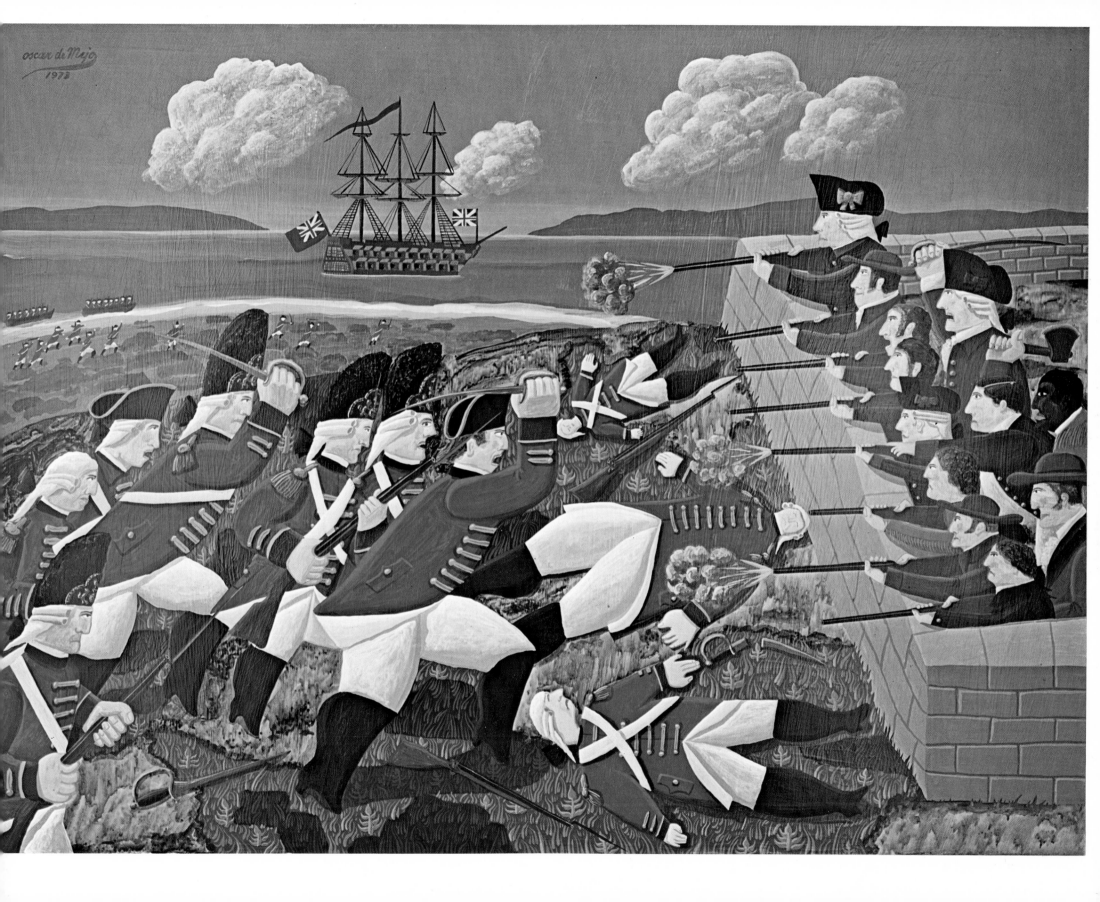

of Boston. By mid-June they had sent several parties of working troops across the peninsula from the city where the land rose in several rugged ridges including Breed's Hill and Bunker Hill. Under cover of darkness they dug redoubts on Breed's Hill, threw up an earth-work parapet and fashioned a shallow flanking trench leading to the water's edge opposite Charlestown.

On the morning of June 17, 1775, the British blinked in stunned surprise to see the upstart rebels dug in so near at hand. Nothing would do but to give these cocky Colonials a swift, sharp lesson with British bayonets and sweep them away.

General Howe, in the early afternoon, took 2,400 men to rout out the 1,600 or so Americans and their six cannons.

Scorning caution, Howe's redcoats marching in parade rank to piper's music started briskly up the hill in the hot sun of a June afternoon.

Old Israel Putnam is supposed to have said it first: "Hold fire! Wait until you see the whites of their eyes. Then up and shoot at their belts. Tear out their bellies, damn 'em." The word was passed along the parapet.

The brisk British troops were a scant fifteen yards from the parapet when the Americans rose and fired a blast of lead and slugs.

Three times the wavering red-coated British moved doggedly forward. Three times the Colonials fired point-blank—until their powder ran out and they scampered down the hill. Breed's Hill it was, though history will forever call it Bunker Hill.

The British counted 1,054 casualties on the stained green slope in front of the parapet. Among them, dead or sorely wounded, was every single officer who had headed up the hill and almost a third of Howe's total command.

The Americans lost 100 dead.

General Gage, who had ordered Howe to the attack simply could not believe it. Howe shook his head in wonder.

While the British straggled back to hole up in Boston the Colonials, naturally enough, strutted and bragged in their pride of victory.

It would be a long time before they had another such sweet taste of victory.

The Die Is Cast:
The Second
Continental Congress

The pleasant days of May, 1775, came and went with no notice whatever from London that the petitions of the First Continental Congress had been seriously considered by either Crown or Parliament.

By June 1, delegates from each of the thirteen Colonies had convened in the handsome comforts of the Pennsylvania State House in Philadelphia for the historic Second Continental Congress.

There could be no question this time that a strong spirit of independent action was in the air. The city of 40,000 people was alive with rumor and debate and a deep sense that events were sweeping toward a climax.

Two major decisions, each of which was to play a decisive role in the birth of the United States of America —and, indeed, in the two centuries of its history— emerged from this Second Continental Congress.

First: the appointment of George Washington of Virginia as Commander-in-Chief of the American Continental Army. The Commission was dated July 19, 1775, and signed by John Hancock, President of the Congress.

Second: The Declaration of Independence, adopted on July 4, 1776; proclaimed publicly fifteen days later. It was the singular historic act of the Congress. It was, in fact, one of the truly great acts of any political body in world history.

Commander-in-Chief of the American Continental Army

On June 14, 1775, the Congress resolved to enlist ten companies of riflemen to serve in an American Continental Army for one year. They further resolved: "That a General be appointed to command all the Continental forces raised or to be raised. For this the Commander would receive $500 a month for pay and expenses."

The choice of a Commander-in-Chief was a serious piece of business. It was imperative that Europe understand the serious purpose of the Congress and of the American cause. Such random actions as Lexington and Concord, the action of Ethan Allen and Benedict Arnold at Ticonderoga, even the better planned and better commanded action at Breed's Hill were, at best, bold strokes without a cohesive plan or a national purpose.

A Commander-in-Chief needed respectability and stature. He should be capable of disciplining an army to be an army, not a rebellious mob. Europe must be convinced that this was a serious, rational movement to establish and to secure certain rights.

There was no dearth of candidates for the job.

John Hancock himself wanted the appointment. Among others who either actively sought the appointment or were available were: Charles Lee, whose credentials included service as a commissioned officer in the British Army. Israel Putnam, an aging veteran of the French and Indian wars in which he had served with some distinction; Artemas Ward, commander of the troops around the city of Boston.

George Washington had attended all the meetings of the Continental Congress—a virtually silent presence impressive in the buff and blue uniform of the Virginia Militia. His presence and his bearing did not escape the shrewd and practical eye of John Adams.

It was clear to Adams, as it was to several of his colleagues, that if the struggle with Britain was to be engaged it must be a truly national effort or it could be easily fragmented and would fail. It was, therefore, critically important that the Southern colonies make common cause with the more vociferous and belligerent New England and northern tier of colonies.

From their earliest history the colonies had developed on different economic and social patterns. The North, with its major sea-ports was an emerging, commercial, mercantile, wage-earning, partly urbanized society. The South was agricultural, based in large part on a society of gentlemen farmers with a greater sense of identity with the ideas and cultures of Europe. Its great wealth was in tobacco. Two other forces were much stronger in the South than in the North: Toryism and the presence of slave labor.

No real national purpose could be made credible or successful unless these thirteen diverse colonies stand and function as one.

What better way to bind them in common cause than the appointment of a renowned and respected Colonel of Virginia Militia to the powerful position of Commander-in-Chief? It was Adams who suggested to Thomas Johnson, a delegate from the border colony of Maryland, that he nominate George Washington. Washington had much to recommend him.

His military experience, while limited, was not without distinction. He had served three years on General Braddock's staff. He had shown himself a serious disciplinarian, an intelligent and prudent commander in the field.

George Washington of Mount Vernon was a man of substance, no mere military adventurer with little to lose and a taste for glory and adventure.

He had served in both sessions of the Continental Congress and in Virginia's House of Burgesses. He was, indeed, a third generation American of considerable stature and presence. Speaking in behalf of Washington's appointment, Adams said:

"His skill as an officer, his independent fortune, great talents and unusual character would command the respect of America and unite the full exertion of the colonies better than any other man alive."

Congress agreed. Washington was unanimously named Commander-in-Chief with the rank of General. He accepted the awesome task with one proviso:

"I beg to assure the Congress that as no pecuniary consideration could have tempted me to accept this arduous employment, I do not wish to make any profit from it. I will keep an exact account of my expenses . . . and that is all I desire."

The Revolutionary Declaration

By Spring of 1776, "rebellion" was a fact of life and had been for at least a year. At Concord and Lexington Colonial militia had fired on British Regulars; on Breed's Hill outside Boston General Howe's troops had been shattered by entrenched Colonials. There was no doubt about it any longer, this was blood and guts armed rebellion.

In chambers of the Pennsylvania State House the Continental Congress must now face the issue squarely: What is this rebellion seeking? Redress from "odious taxes?" Representation in the British Parliament? Compromise? Peaceful solutions?

The sentiment of the Congress was obviously soaring toward a higher goal—a clean break, a new nation totally independent in its own right.

As Spring warmed to early Summer debate went on. North Carolina reported that its delegates had been instructed to vote for independence. Other delegates took up the cause, still others dawdled, waiting instructions from home.

On June 7, Richard Henry Lee of Virginia offered a

THE DECLARATION
OF INDEPENDENCE
JULY, 1776

The committee of five meets in a tranquil park—Jefferson with his volume of Plato. The spirit of Liberty, towering female virtue dominates the scene—even Ben Franklin.

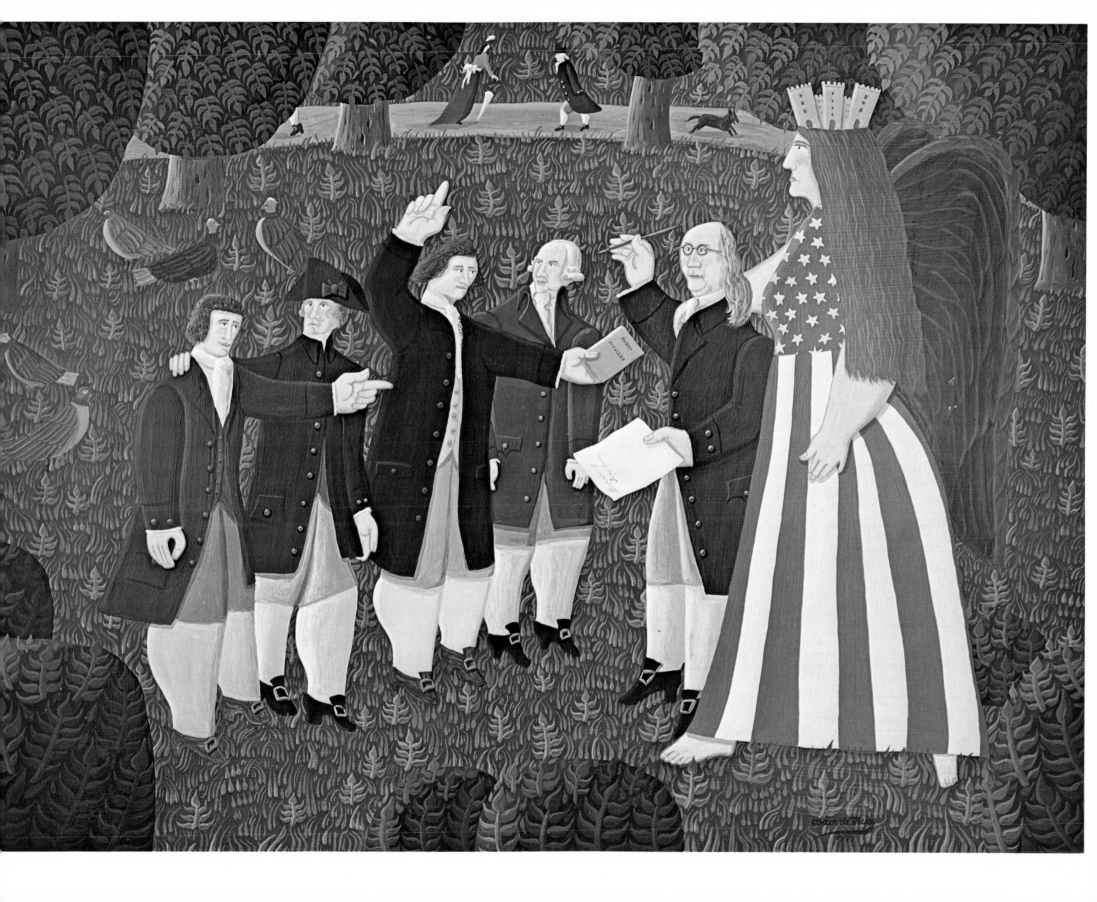

resolution that cut through the fog and proposed simply and strongly that "the united Colonies are, and of right ought to be, free and independent states." The fiery Virginian, the "Cicero of America," had cleared the air. The issue was now in sharp focus.

After four days of debate the Congress, on June 11, 1776, appointed a committee to "prepare a declaration" of independence. Members of the committee were: Thomas Jefferson, Benjamin Franklin, John Adams, Roger Sherman and Robert Livingston. The first four were well known and out-spoken advocates of independence. Livingston, of New York, was regarded as a moderate.

The committee by unanimous vote asked Thomas Jefferson to draft the document. Jefferson had been a delegate from Virginia to the First Continental Congress and had written the Colonial answer to Lord North's "Proposal for Reconciliation." He had returned to Virginia in December, 1775, and arrived back in Philadelphia on May 14, 1776, scarcely a month before undertaking his historic assignment.

Jefferson did his writing in a second story room in the home of a young German bricklayer named Graff at a portable desk of his own invention.

There is considerable evidence that the five-man committee met regularly to discuss the work in progress and that both Franklin and Adams suggested changes in language and in emphasis. On June 28— scarcely more than two weeks after it was started —Jefferson's draft was delivered to the Congress.

Meantime, strenuous efforts had been made in the Congress itself to convert the fence-sitters and the uncommitted delegates to endorse the principle of independence. On July 2, Congress approved in principle Lee's resolution for independence. The vote was unanimous, with one exception—New York's delegates abstained from voting.

On the following day Jefferson's Declaration was submitted to the Congress and debated for two more days. Congress made several changes, one of major, long-term importance: Congress struck out of Jefferson's document a strong denunciation of slavery and the slave trade which Jefferson had laid squarely at the feet of George III.

On the evening of July 4, 1776, the Declaration of Independence was reported out of committee and agreed to by the full Congress with orders that it be "authenticated and printed."

In the next few weeks the Declaration was publicly proclaimed on several occasions to audiences whose reactions were varied.

On July 8, in Philadelphia Col. John Nixon, of a militia unit known as the Philadelphia Associators, read the Declaration from a temporary platform in the yard of the State House. Few were present. It was hardly news in Philadelphia where every house and tavern had been filled with argument on the subject for more than a year.

In Boston, on the 19th of July, Thomas Crafts, a friend of Paul Revere and Sam Adams read the Declaration from a balcony of the State House to a huge and enthusiastic crowd. Abigail Adams later wrote to her husband, John, in Philadelphia: "The bells rang and privateers fired batteries, cannon were discharged and every face appeared joyful. The King's arms were taken down from the State House and burnt. Thus ends royal authority in this State and all the people shall say Amen."

Washington's troops had moved from Boston to New York and there, on July 9, the Declaration was read to regiments of half a dozen states. In his formal orders Washington said: "The General hopes this important event will serve as fresh incentive to every officer and soldier . . . now the peace and safety of this country depends solely on the success of our arms."

But the larger fact was clear to the world—Americans had taken a revolutionary step in the long history of how people govern themselves.

The War Comes to New York and Long Island

The battle of Long Island in August 1776, was the first armed confrontation of America's Continental Army with the might of Britain since the colonies had boldly declared their independence scarcely more than a month earlier.

It was General George Washington's first taste of the awful responsibility of "supreme" command and of the massive power he was facing.

In many ways Long Island was to influence the pattern of Washington's strategy for the rest of the long war.

The British build-up began in late June when Admiral Lord Howe arrived in New York Bay from Halifax with the vanguard of what was to be the largest expeditionary force ever sent out of Great Britain.

By mid-August the British camp on Staten Island held an army of 24,000 Regulars and 9,000 Hessians —trained professional soldiers, well disciplined, well armed, fully equipped and under seasoned command.

Supporting this force were more than 30 armed naval vessels carrying more than a thousand guns, plus hundreds of transport ships manned by nearly 10,000 seamen.

It was a formidable sight. The bay itself a "forest of masts." Staten Island a bristling concentration of British arms.

New York in 1776, was a city of 25,000 people covering about one square mile on the Southern tip of Manhattan Island. Its chief military importance was its waterways—the harbor itself, the majestic Hudson offering a tempting route deep into the Colonies toward British Canada, the East River separating Manhattan and Long Island.

To defend New York, Washington commanded a Continental Army of about 19,000 largely untrained, untried, amateur soldiers haphazardly armed. Not a single warship or armed transport vessel was available to them. Strenuous efforts had been made through the early Summer to place artillery batteries on lower Manhattan and on both the New York and New Jersey shores of the lower Hudson.

But the Continental force was painfully thin and its position made even more precarious by Washington's decision to split his force. The larger body of troops he placed on Long Island, the balance he kept on Manhattan—offering the British an easy opportunity to put a naval force in the East River isolating the Americans from one another.

Washington's plans for Long Island centered on Brooklyn Heights where major earthwork fortifications were manned by about 5,000 men under command of Israel Putnam.

Deployed on the flatlands south of the Heights were two forces of riflemen spread out in the woods and farmlands. The American left was under command of John Sullivan of New Hampshire. On the American right, with his flank of the East River, was William Alexander of New Jersey, better known as Lord Stirling.

It was the third week in August before these commands had been established and the troops put in place.

August 22 was a clear, hot day. At first full light the British force began its move toward Long Island— frigates under sail followed by a procession of barges, nearly 100 of them, shuttled from Staten Island bearing British Regulars of the 17th Light Dragoons, Black Watch Guards and the first wave of Hessian troops to set foot on American soil.

By late afternoon 16,000 men were landed on the beaches—an awesome sight to Washington and his staff watching from Manhatttan.

Only one natural force favored the Continentals—a contrary wind which blew steadily all day and prevented Howe from tacking up the East River. The weather, in fact, prevented Howe from reenforcing his troops on the beach until August 25. On that day several thousand more troops, including Hessian Grenadiers and about 30 field-pieces were landed.

In the dark of night on August 26 the British made their move. Fifteen regiments of regulars and Hessians with more than 20 field pieces moved out in a column of nearly 12,000 men.

Covered by darkness the force swung away from the American center in a wide arc to the right. As the sun rose the British had flanked Sullivan, hit him heavily from the rear and rolled up his left flank. It was a shattering blow. Sullivan's force was crushed and broken and fled south.

A signal gun sent the Hessian, British and Scot regiments into the American center and right. It had the makings of a rout. Continentals found their long rifles clumsy and slow to fire. They were without bayonets and were taking a bad beating.

Late in the morning Washington was ferried over to Brooklyn but there was little he could do except try to manage a mauling. There was one bright spot:

Lord Stirling, whose command included Maryland troops led by Smallwood and a Delaware contingent under Haslet, was holding firm in spite of heavy pressure. But the rest of the field was in deep trouble. Stirling sent all of his troops into orderly retreat except for 200 Marylanders under Major Mordecai Gint. This tiny force he led in a desperate counterattack to delay pursuit.

By noon the fight was broken off. Americans who had survived the rout poured into the Brooklyn Heights earthworks. The British began to dig in, build earthworks of their own and send glittering reports of victory back to London.

Briefly Washington believed he could hold Brooklyn, but only briefly. On August 28th, the weather turned foul, with heavy wind-lashed rain from the Northeast.

The Continental luck was holding. It turned out that one of the regiments shipped to Brooklyn was that of John Glover, the Marblehead fisherman. Glover and other Massachusetts units under Israel Hutchinson scoured up every small boat in the area. It was time to escape.

As darkness fell and the rains continued, they began the slow and silent work of getting the Continentals across the East River to Manhattan. Nothing cooperated as well as the weather, for the rain was followed by dense fog which blanketed the river and its shores.

It was four o'clock in the morning and the Heights were empty except for a few abandoned field pieces before the British knew what had happened and then they guessed badly. A Major wrote back home to say: "The whole American army fled to New England, evacuating all of New York."

Long Island, the first battle fought after the Declaration of Independence was far from a victory—but it did set a pattern which Washington's armies were to follow throughout the war: Fight, but above all, survive. Survival to fight again is critical to the citizens' army engaged in long rebellion against rich and powerful forces.

THE BATTLE
OF LONG ISLAND
AUGUST, 1776

First terrible confrontation of nations in the real War. Hessian dreams of far away Cologne; an American dreams of home and family. The trees are full of hiding riflemen. All set in a luscious green world and the bosomy spirit of Liberty points "Onward."

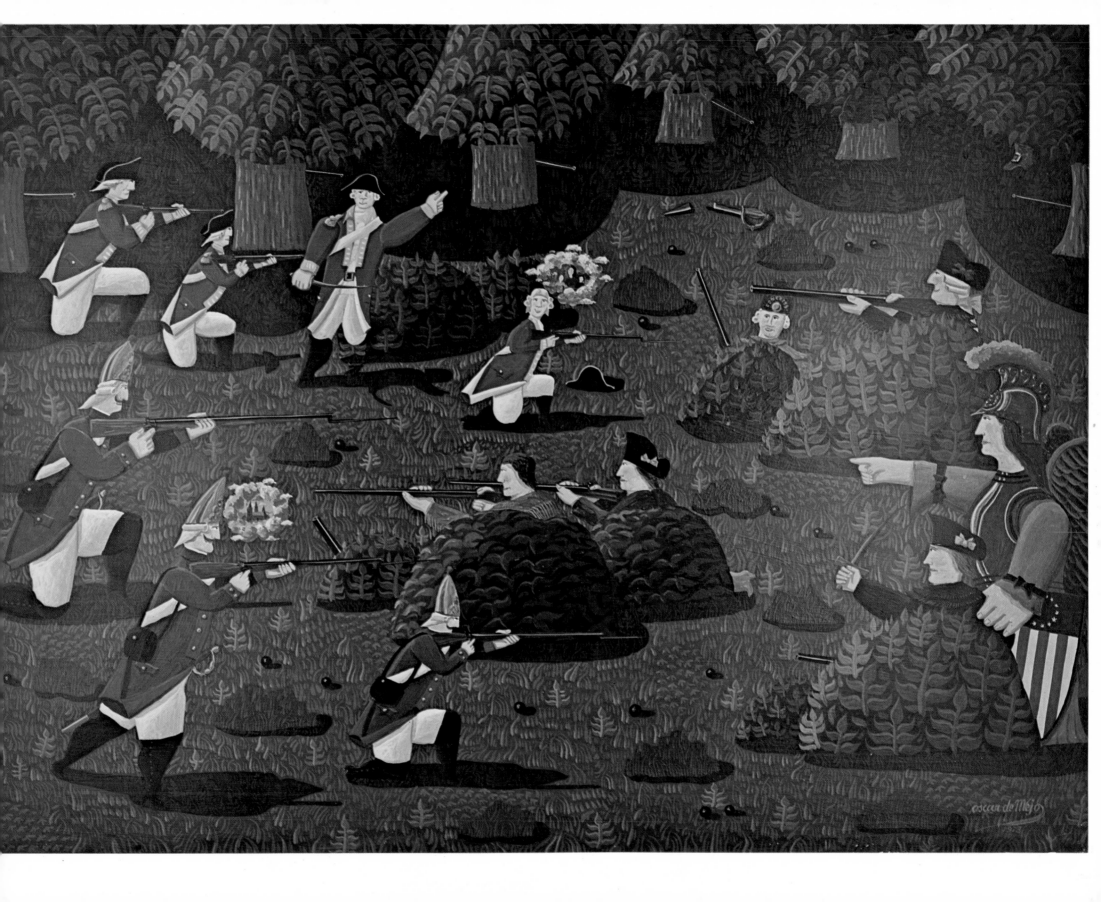

The Long Road to Trenton

Washington had pulled off a miracle. Trounced by the strongest force ever sent out from Great Britain he had escaped with nearly a whole hide. His losses were under 1,500.

A solid case can be made, indeed has been made by good historians, that Washington's escape from Brooklyn Heights in August '76 was the beginning of a long and crafty retreat that took the Americans all the way from Manhattan, through Westchester into New Jersey and finally to Pennsylvania in the dead of Winter.

This was not the desperate flight of the defeated, but the toughening pilgrimage of an army whose purpose was survival.

The journey started very badly indeed in mid-September, 1776, with American forces routed and fleeing in disarray.

After the escape from Long Island, Washington had dawdled. Again he split his forces and lingered far too long on Manhattan for reasons which are still unclear. Nathanael Greene urged him to abandon Manhattan. Common sense urged it too as Howe occupied the East River Islands now called Welfare, Randall's and Ward's. British vessels of war moved unimpeded in both the East River and the Hudson.

The American army on Manhattan was in three widely scattered positions.

Washington with his main force, about 9,000 men, had moved to strong ground on the rocky plateau of Harlem Heights just north of the present site of Columbia University.

Five brigades, mostly militia, were strung out in shallow trenches along the East River in the neighborhood of Turtle Bay and Kip's Bay, from about East 50th Street south to East 32nd Street, in today's terms.

Israel Putnam, with about 4,000 men of John Sullivan's Brigade and Knox's artillery units plus great stores of arms and supplies, were left virtually isolated on the southern tip of Manhattan in the city of New York.

On September 15, the British, after a thunderous barrage from 70 heavy cannons, slammed a force across the East River to hit Kip's Bay. The thin force of American militiamen was no match for this overpowering onslaught. They broke and ran in almost total disarray; finally most of them fled North on the Post Road, now Lexington Avenue.

Putnam, in danger of being cut off and trapped, moved to get his men and stores out of town as fast as possible. Young Aaron Burr, Putnam's aide, guided him to a little used road on the West side of the island. After long hours of slogging and two skirmishes with British scouting parties, Putnam and his bone-weary troops clambered into Harlem Heights long after darkness had fallen.

Fortunately General Howe was in no great hurry to pursue the fleeing Americans. After a short, hot skirmish in open country, about where the Public Library now stands on Fifth Avenue, the British Command called it a day. Howe and his staff stopped off at the home of Mrs. Robert Murray—the Murray Hill Murrays—for a pleasant social evening.

Washington dug in on the Heights. Howe and the British returned to New York. Within days somebody, British or American, set fire to the city and left lower Manhattan burned and scarred for the rest of the war.

On the morning of September 16, American scouts at Harlem Heights made contact with elements of the British 42nd Highlanders. By noon the British were re-enforced by Grenadiers of the 33rd Regiment and two companies of Hessians.

For the next two hours the fight was spirited. More important, the Americans who had fled in panic the day before now saw the British back away and retreat. This time, to Washington's elation, it was the Americans who were in hot pursuit.

It was not much of a battle but it was a heady boost to see Americans stop British and Hessian Regulars in their tracks and drive them back a mile or more in retreat.

Howe took almost a month before he finally made a move in force out of Manhattan. He decided that Washington's position on Harlem Heights was too strong for a frontal attack. The last thing Howe wanted was another Breed's Hill.

In mid-October Howe began his move through Throg's Neck, up to Pell's Point and into New Rochelle. It was a move that put the Americans in great peril of a flanking action which could tear them up from the rear.

Washington and his staff conferred in the Jumel Mansion on the high bluffs above the Hudson River. John Sullivan and Lord Stirling were there. So was unpredictable Charles Lee, just back from Charleston where Colonel Moultrie had turned back a British fleet in Charleston Harbor.

The council of war was unanimous: Get out of Manhattan fast and head for White Plains. But there was one exception. It was agreed to leave about 2,200 troops to garrison Fort Washington on the east bank of the Hudson.

Lack of transport made the journey to White Plains painfully slow and ragged but Washington, with about 13,000 men, finally took position on a series of hills overlooking the village.

On October 28, Howe attacked an American force under General Alexander McDougall which was dug in on the extreme right of Washington's lines. It was the same old pattern, the militia units broke and ran, the Maryland, New York and Delaware Continentals held well and were able to withdraw in good order.

So Howe won Chatterton's Hill but Washington's main army simply moved to higher ground at North Castle, still in control of White Plains.

British historian Trevelyan was caustic about Howe:

"Since Howe left Staten Island seven weeks ago with an irresistible army and a fleet which had nothing to resist he has traversed from point to point a distance of exactly 35 miles."

More important, Washington's Continental Army was essentially intact.

On the night of November 4, to everybody's surprise, Howe began to pull out, 20,000 strong, heading back toward Manhattan. Washington, believing Howe was moving to New Jersey, promptly moved his own forces across the Hudson.

On November 16, Howe made his move. With a combined force of British and Hessians he stormed Fort Washington on upper Manhattan capturing its garrison and its precious stores. Four days later he slipped across the Hudson and clobbered Fort Lee.

With these trophies in hand, and Winter weather setting in, Howe called it a day. He turned pursuit of Washington over to Cornwallis and decided to Winter in New York.

Cornwallis pressed Washington hard as the December cold clamped down on New Jersey. Newark could not be held and Washington fled across the Raritan River for a breathing spell at New Brunswick. But Cornwallis kept the pressure on. In the first week of December, Washington managed to get his dwindling army across the Delaware into Pennsylvania.

The year was coming to an end—so were several thousand one-year enlistments. Each day, each week Washington's forces were a little thinner and strenuous efforts were made to persuade the Continentals to sign on for another year.

In Philadelphia Congress had become exceedingly jittery. On December 12, after passing resolutions which gave Washington total authority to prosecute the war—almost dictatorial power, in fact—the nervous politicians moved themselves temporarily to Baltimore.

Washington was sensible enough to know that Philadelphia was not a great military prize and that Howe was unlikely to bestir himself. But above all, Washington knew it was high time for a victory, almost any kind of victory.

Washington Crosses The Delaware

A citizens' army fighting on its own ground is in much closer touch than the invader can ever be with the every-day life and gossip of the towns and villages.

As Christmas 1776 approached, word trickled in that the 1,400 Hessians under Rall and Knyphausen at Trenton were passing the snowy days and long cold nights in home-sick revelry.

Washington decided to gamble. He headed back toward the ice-choked Delaware River. Once again John Glover and his Marblehead boatmen were critically important. They commandeered and manned a small fleet of Durham boats. These craft, unique to the Delaware, were about forty to fifty feet long, eight feet wide and only about three feet deep. The largest of them could carry up to fifteen tons, ideal for men, artillery and horses.

At full dark the boats were loaded and shoved off. It was a bitter cold, overcast night, the river was choked with ice floes that battered the craft. The plan called for all troops to be across the river by midnight but it was well past three o'clock when the last men were ashore. It was after four o'clock in the morning of December 26, before the troops were ready to march the nine miles to Trenton.

Colonel Johann Gottlieb Rall, senior Hessian commander in Trenton, had spent the evening at a supper party in the home of a wealthy merchant of the town. Wine and cards and good fellowship stretched the party well into the night. About midnight a caller arrived seeking Colonel Rall. Unable to get past the servants, he left a note telling Rall the American army was on the move. Maybe Rall read it, maybe he didn't, but he shoved it in his pocket and went on with the party. The note was found, still in his pocket, two days later after Rall had died of his battle wounds.

When Washington attacked the surprise was total. Fighting raged through Trenton's streets for less than two hours before the Hessian garrison surrendered. American forces suffered fewer than a dozen casualties. The Germans had thirty killed, including Rall, and 1,009 surrendered.

It was a victory of morale far more than of military importance. But it was a victory, clear and clean. To make it even more impressive Washington later had his captured Hessians marched through the streets of Philadelphia to a rousing response from the people.

Sweet as it was, Trenton was hardly more than a daring raid. Washington needed another swift stroke.

General Cornwallis had reacted fast to Trenton and was hurrying forth to attack Washington's army of 5,000 men before it could dig in for a firm stand.

But Washington, the wily fox hunter, was a few strides ahead this time. On January 3, 1777, he made his move. Leaving enough men and campfires to lure the British he took to an old and frozen trail with men and artillery, stole around Cornwallis' flank and was in Princeton before its defenders knew what hit them.

With two quick victories Washington's long retreat from Brooklyn Heights came to a halt—at least long enough for a winter pause in Morristown.

December 1776, was a pivotal month in the American struggle. The military events at Trenton and Princeton were highly visible and gave the people and their cause a needed boost. Congress even moved back to Philadelphia early in 1777.

But there was another event even more important in the long run which was little noted at the time. On December 21, 1776, Benjamin Franklin arrived in Paris as envoy of the Continental Congress, seeking the support of powerful France in the cause of American Independence.

WASHINGTON
CROSSES THE DELAWARE
DECEMBER, 1776

"March on," the painting says—firm and straight and determined. Ignore cold and ice. Washington's spirit is in everyone—and the "Hand of God" is over all. Onward!

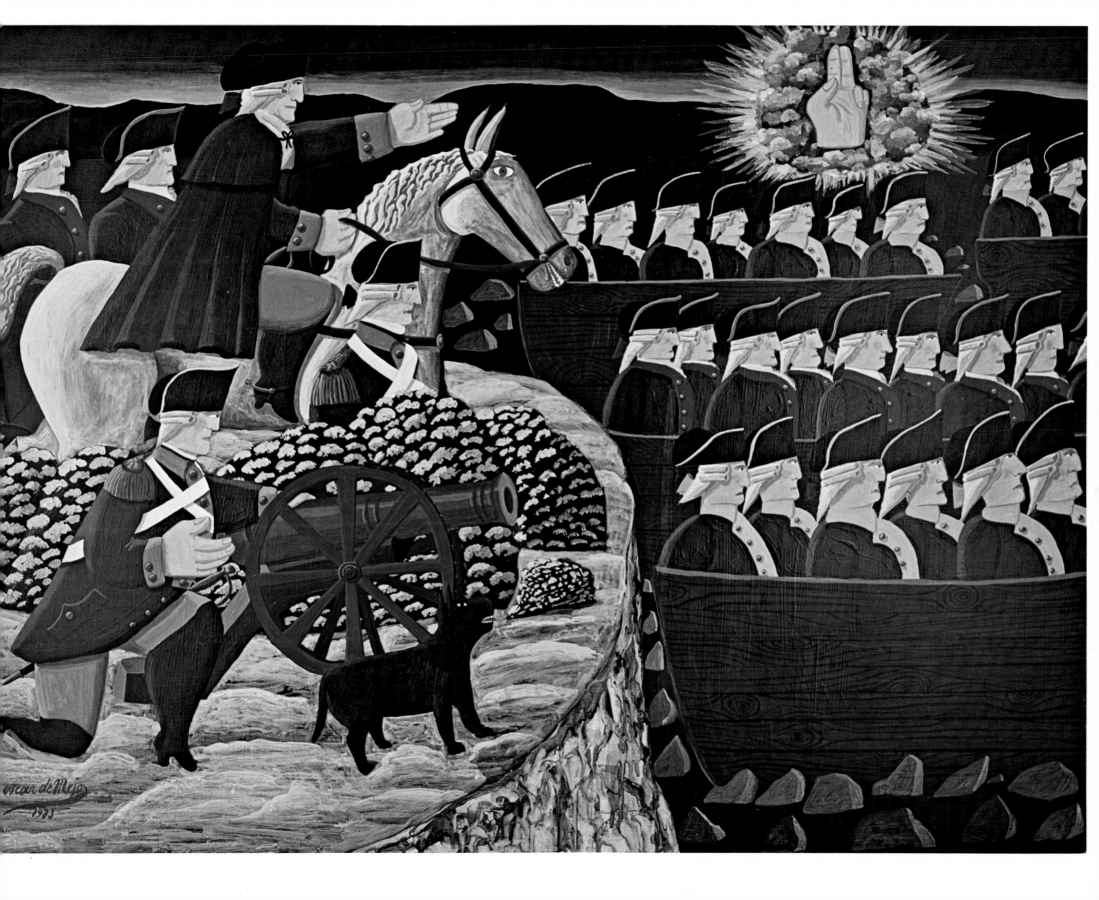

1777—The Year The British Might Have Won It All

1776, the first hard year of America's declared independence, drew to a cold unpromising end. Princeton and Trenton had been cheering victories but only tiny pecks at the power of British arms.

Washington's army dwindled to a mere 4,000 men who made winter camp near Morristown, New Jersey, miserably short of all provisions, clothing, arms and sense of purpose. Washington put them to work building a fort. These first American soldiers were green but they knew a boondoggle when they saw one—as G.I.'s have ever since. They christened the place "Fort Nonsense."

In the early months of 1777, things began looking up a bit. Fresh supplies arrived from France along with cheering word that 34 more ships loaded with bales of cloth, shoes, gun-flints, kegs of powder and arms were on the way.

An exchange of prisoners of war was arranged and some tough, battle-proved officers were returned to duty. Enlistments were extended, new recruits trickled in along with fresh companies of militia.

By Spring a new bloom was beginning to show and the Continental Army felt its juices stirring again.

The first move was out of Morristown into Bucks County, Pennsylvania where a dashing young French officer made his first appearance. He was a nobleman of remarkable lineage, the Marquis de Lafayette, just turned twenty years old; so stirred by the bold winds of America's bid for Independence that he fled France and asked only to "be near the person of General Washington until such time as he may trust me with a Division of the army."

As the Summer of 1777 warmed, the overall situation was about like this:

The British under Howe had overwhelming superiority in military and naval power—with no over-all strategy for victory.

Washington had even less grand strategy and pitifully less military power.

But all Washington had to do was hang on and keep his fighting force alive. As long as the Colonies remained united Britain faced a staggering military task.

And the longer the struggle went on the more certain it became that France or Spain, or both, would intervene openly.

So London was more than ready, was eager in fact, to listen when a man like General John Burgoyne laid before the Colonial Secretary a bold and detailed plan which could win the war quickly—this year, 1777.

"Gentleman Johnny" Burgoyne was no ordinary officer. He had fought well in Spain during the Seven Years War, married into the wealthy and influential Stanley family and had become a favorite of King George.

Burgoyne was a man of charm and talent with a flair for visibility. A competent officer, a dashing social figure and a dramatist good enough to have a play produced by the great Garrick.

Burgoyne arrived back in Canada early in 1777 with his plan already enthusiastically approved in London —which did little to endear him to Sir Guy Carleton, himself a superb military man and Governor of Canada.

Burgoyne's plan for victory was simple and practical. Using British army forces already in Canada, plus Hessian and Indian recruits, he would push south through Lake Champlain to Ticonderoga and then on to the Hudson River.

Howe was to provide forces moving north from New York to link up with Burgoyne at Albany and thus split the Colonies.

It was a grand plan. But somehow the word never got clearly through all the chains of military and political command to Howe in New York. Howe knew the

facts, there is no doubt about that. But he either believed, or chose to believe, that Burgoyne was running an entirely separate campaign to which Howe might, at some point, be asked to provide support.

Howe had his own grand plan, aimed at flashier, more visible victories than hacking through the wilderness of Northern New York state.

One thing the Burgoyne plan did not have was secrecy. Months before the action started Washington knew most of its details as, indeed, did many informed Americans. Arthur Lee, busy advancing the American cause in Paris, had sent details of the campaign by letter to members of Congress in Philadelphia before Burgoyne ever left London.

As the promising Summer of 1777 developed, Howe and Burgoyne fought two separate wars—both had moments of victory—but when it was all over Britain had lost forever the momentum of total victory in America.

The two campaigns started in mid-June, within a week of each other.

Burgoyne started south from Canada on June 17 with a total force of nearly 8,000 including about 3,000 Hessians and a force under St. Leger which consisted of 675 Redcoats and as many Indians, scouts and warriors, he could recruit.

Within three weeks this formidable fighting force, well equipped with artillery and rich in supplies, had come down through Lake Champlain and achieved an easy, important victory at Fort Ticonderoga.

Tough old Ticonderoga had been manned by a force of 2,200 Continentals and militia commanded by General Arthur St. Clair who made one fatal miscalculation. He and his engineers decided that Sugar Loaf Hill, just south of Ticonderoga and commanding it, was far too tough a wilderness to be accessible. On the night of July 4, the British proved him wrong. When daylight revealed British guns on its heights St. Clair

could do nothing but leave, and it needed a lot of luck to do that. Burgoyne always the showman, renamed Sugar Loaf "Fort Defiance."

During the night of July 5, St. Clair and his troops began their escape across a bridge of floating boats. The British, after occupying Ticonderoga, decided to pursue. At Hubbardston, St. Clair, with enthusiastic help from local militia units fought a brisk rear guard action which cost the British nearly 800 casualties before the skirmish was over. More important, the decision to pursue the Continentals led Burgoyne's forces away from Lake George and the relatively easy water route to the south. They found themselves in some very heavy going in rough country. The diversion was to cost them dearly.

While Burgoyne was hacking his way through the northern woods, Howe, on July 5, loaded his troops onto transports in New York harbor. As luck would have it, they had to sweat out 18 windless days in cramped ships becalmed in the harbor. A week before he sailed out of the harbor Howe knew Ticonderoga had fallen.

For more than three weeks Washington had to guess where Howe might turn up next. Oddly enough he had better intelligence on Burgoyne coming down from Canada than he did on Howe whose movements he could literally watch—until the British fleet disappeared at sea.

Finally the word came. Howe's fleet had entered Chesapeake Bay, it became clear Philadelphia was the target and that Howe would probably land at Elkton, Maryland. It was time for Washington to move.

On August 22, Howe's troops were landed at Head of Elk, weak and weary after seven weeks at sea in cramped vessels under a broiling Summer sun. Philadelphia was still 60 or 70 miles away.

Howe was forced to rest, scout up transport, replace cavalry mounts and generally get into fighting shape.

On August 24 Washington rode at the head of his American army as it marched through the cobbled streets of Philadelphia on its way to head off Howe. For more than two hours the main body of Washington's army flowed along Front and Chestnut streets in glowing late summer weather. It was a pleasing and reassuring sight to those who lined the route.

It was September 16, before the two armies met along Brandywine Creek. It was the same old story. A scouting force of Welsh Grenadiers under Major Ferguson engaged American forces near Chad's Ford.

The engagement was small but heated and drew support from other American units. Meantime Howe's main armed curved upstream, crossed at Brandywine Ford and rolled up Washington's right flank.

But the day was not without its bright spots. Nathanael Greene with a Division of Virginians had shored up Sullivan's sagging right wing. Anthony Wayne had fought the British to a standstill in the American center and, once again, Washington had extricated his Army in good shape, virtually intact. As night fell they retreated in good order.

There was plenty of fight left in the American forces. As Howe swung to the left of Philadelphia with British and Hessian forces, American cavalry under General Casimir Pulaski moved quickly to head them off. Two infantry units under Anthony Wayne and William Maxwell joined the fray and for a while it had all the makings of a major fight until a slashing cloudburst of rain bogged both armies down in a knee-high quagmire.

Washington still had an army in the field, but there was no doubt that the British would soon be in Philadelphia in ample time to bed down for winter.

Congress once again moved out, first to Lancaster where it stayed only briefly and then on to York, Pennsylvania.

On the night of September 20, General Anthony

Wayne had his forces bivouacked at Paoli—less than three miles from Wayne's home. In the dead of night a British infantry force commanded by General Sir Charles Grey, armed only with bayonets on flint-less rifles, fell silently upon the sleeping troops. Nearly 300 of Wayne's Americans were killed or wounded in the massacre. "No Flint" Grey had his small, bloody victory but he created a formidable foe in Anthony Wayne who, from that day, was indeed "Mad Anthony."

Howe with his glittering force of British and Hessian forces marched into Philadelphia on September 26. To the British it was a victory to be hailed and exploited—His Majesty's forces were solidly established in the Capital of Colonial America. Total victory could not be far away.

To most Americans the situation was far different. There was no tradition of a "National Capital" or of a nation for that matter. Philadelphia was, it is true, America's biggest city. Its 40,000 inhabitants made it the second largest English speaking city in the British Empire. But it was just a city, in a country where cities were not especially revered and Congress could function just as well, or just as poorly, in York.

Burgoyne's separate war in the North, which started so brilliantly with the capture of Ticonderoga, began to suffer from three major errors:

First: Burgoyne and his formidable Hessian troops were enticed into pursuing St. Clair when he fled from Ticonderoga. This led them away from the easy water routes through the lakes into unknown country alive with hostile New England militia getting hotter by the minute.

Second: British use of Indian troops under St. Leger was bad enough, but Burgoyne waved the bloody flag visibly when he issued an order instructing Indian warriors to go easy with the tomahawk on the "very young and the very old." Nothing so aroused the New England farmers to take to the rifle and turn up in ever growing numbers to join General Gates, Benedict Arnold and tough old Daniel Morgan.

Third: Howe, busy taking bows for his success at Philadelphia—and even busier in the social whirl

with Mrs. Loring—did nothing for Burgoyne except to dispatch a modest force under Clinton which went up the Hudson as far as Kingston and then turned tail and hustled right back to New York.

Thus the precious Summer of Johnny Burgoyne was wasted thrashing around in the deep northern wilderness.

Burgoyne's progress was further slowed by his own imperial habits of solid comfort, full meals and ever-present female companionship. His entourage used thirty wagons, complete with wine cellars, nappery and a lady universally known as "Mrs. Commissary" who was his traveling mistress. The sound of champagne corks was heard with greater frequency than the sound of rifle fire.

By mid-September, Burgoyne had moved South through Saratoga toward the ever-growing force of General Gates. By this time it is a fair estimate that Burgoyne's forces had diminished to about 6,000 and he was out-numbered nearly three to one.

On September 19, Burgoyne launched an attack of three columns in an effort to outflank Bemis Heights. The British and Hessian units ran into an American force at Freemans farm near Saratoga under the restless command of Benedict Arnold. In a bold hit-and-run attack Arnold cut the British up and left them with more than 600 casualties.

When word finally reached Burgoyne that Clinton had arrived at Kingston, then turned and headed back to New York, he had no choice but to try and break through the American lines. He tried again at Freemans Farm on October 7. By this time the Fall rains had started and the British, fighting in unknown country, against a much larger force, suffered very heavy losses and pulled back to Saratoga.

It was apparent to Burgoyne that he could go no further. Howe had failed him. The country itself had been a rugged and unyielding foe. The New England militia had proved tough and wily. His losses had been great, his supply lines were long and undefended and winter was not far off.

After five days, Burgoyne opened surrender talks on October 13.

On October 17, Burgoyne and his British and Hessian forces surrendered to General Horatio Gates.

To the very end Johnny Burgoyne was a bold and resourceful spirit. In talks with General Gates and other American officers he worked out a surrender that was not quite a surrender. He proposed "The Convention of Saratoga" which would allow his captured troops to be returned to England and new troops be sent to America in their stead.

The showman in Burgoyne persisted. In the wild Autumn country of upstate New York, his forces ceremoniously laid down their arms. Burgoyne, resplendent in crimson and gold, wearing a brilliantly plumed hat, stood beside tired old Horatio Gates as the disarmed troops passed in review.

Some wondered at the willingness of Gates to accept the so-called "Saratoga Convention" instead of unconditional surrender. Gates was to say later that he was not certain that Clinton or Howe might not still send forces to Burgoyne's aid, plus which he desperately wanted all those British arms and supplies.

In the end it made little difference. Congress, elated at the turn of events, threw all sorts of roadblocks in the way of the "Convention." One issue which was never fully resolved: If Congress and the British government signed such a convention was that not *de facto* recognition of American independence?

The whole thing dragged out for years. Some troops were returned to England. Others were imprisoned here; still others made easy "escapes." Several hundred of the German troops stayed on in Central Pennsylvania after the war ended.

Burgoyne's defeat at Freemans farm was noted with great interest in France, and with some shock in London. There is little doubt that it was the beginning of the end for the British cause in America. But there was still a long road to go before that became entirely clear.

SURRENDER AT SARATOGA
OCTOBER, 1777

"Naive" art sees cause and effect, not simply events. "Dandy John" Burgoyne hands a shrunken sword to tired General Gates—but more important, in the upper realm George Washington confronts George III and "God's Eye" knows the outcome.

The Hard Winter At Valley Forge

As the Autumn of 1777, slipped into November and the first snows of Winter, Washington's army was nearly 10,000 strong. After the surrender of Burgoyne the American troops who had fought in the brigades of James Varnum, John Glover, the troops loaned by Washington to Daniel Morgan, and the units led by Benedict Arnold all began trickling back into Pennsylvania.

But it was nearing year's end and thousands of men were close to the end of their enlistments.

The hard and far flung campaigns of the Summer had taken their toll of arms, equipment and men. Blankets were scarce, at least a thousand troops were without shoes of any kind and thousands more were barely shod. Food was short because transport was unpredictable. It was, indeed, an army that lived largely by its wits and the willingness of its commanders to scrounge.

In York, Congress was about to adjourn and its members return home. Most officers and soldiers of the Army would have been glad to join them.

The Winter of 1777-78 was one of extreme contrast for the British and American armies which had been facing one another in the field for more than two years.

General Howe and his officers were installed in the comforts of Philadelphia where their hard British money bought most of the comforts and pleasures sought so avidly by the soldiers of every war known to history. In short, life was warm and good; food and drink flowed easily.

Twenty-odd miles to the northwest of Philadelphia, where the Schuykill River and Valley Creek flow together, is a rolling two-mile plateau of land on which an old forge was located. Travelers who forded the Schuykill to cross this land called it Valley Forge.

In early December, Washington began the movement of his armies from Whitemarsh, where they had temporarily encamped, to Valley Forge where they would go into Winter quarters. The choice was made because Valley Forge was close enough to Philadelphia to keep an eye on Howe but, being high and secluded, seemed safe from surprise attack.

The move took almost two weeks. Horses were in short supply. Wagons were in short supply. Food had a strong tendency to flow toward the hard British money in Philadelphia, not toward the promissory paper money of Valley Forge.

The main body of Washington's troops arrived at Valley Forge on December 19, in the midst of a heavy snowstorm. It was obvious the Winter could not be spent in makeshift tents. Washington, noting that the one thing in long supply on the plateau was wood, set the men to building log cabins.

These primitive structures were totally unknown to most of the Continentals. The log cabin made its first appearance in this country among the Swedes along the Delaware. Washington instructed the troops in the mechanics of building them, a task which required only the simplest of tools and virtually no nails.

Each cabin was sixteen feet long by fourteen feet wide with walls six and a half feet high. Into each corner three bunks were built. Groups of twelve men were assigned to build the cabin they would occupy.

Row by row the cabin-city rose with remarkable speed. Quartered in groups of twelve with additional buildings for officers and hospitals, the army required almost 1,000 buildings. Most were completed within a month.

Food, clothing and supplies did not materialize so easily. There was never quite enough of anything. Even water had to be hauled up from the rivers in a laborious two-mile round trip.

At the heart of the matter was the simple fact that Congress had never created a truly effective governmental authority for the maintenance and welfare of the Continental Army. The first Board of War, consisting of five members, was established as early as July, 1776, but spent most of its time and energies worrying about the possibility of a military dictator!

A new Board of War, including three appointees from outside the ranks of Congress, was approved in late 1777, just a month before the army arrived at Valley Forge.

The tragedy is that much of the scarcity and suffering at Valley Forge was unnecessary. There was enough of everything, if only it could be delivered where and when it was needed. In France, for example, and as close as the French West Indies, large quantities of clothing, shoes and other materials were held up in red tape and squabbles over contracts and the claims of rival agents.

When General Anthony Wayne dipped into his own personal fortune to buy substantial quantities of new clothing for his men, the bureaucracy refused delivery because the transaction was "irregular."

It is also painfully clear that most civilians looked the other way, intent on "business as usual."

With painful slowness changes were eventually made. Nathanael Greene reluctantly agreed to serve as Quartermaster General, insisting that he retain his rank as Major General, have the right to name his own staff and not be tangled up in a maze of red-tape over accounts and procedures.

He was finally confirmed on March 2, 1777, and things began looking up a bit.

But there was one, vital and positive force at work in the grim Winter of Valley Forge.

It began on December 1, 1777, at Portsmouth, New Hampshire, where Frederick William Augustus Henry, Baron von Steuben, arrived bearing letters from Benjamin Franklin which described him as a Lieutenant General in the service of Frederick the Great of Prussia.

von Steuben, two years older than George Washing-

ton, was a distinguished veteran of the Seven Years War, wounded at Prague and singled out for special training by Frederick the Great himself.

With commendable modesty von Steuben offered himself as a "volunteer" to serve under Washington without the troublesome protocol of rank. The doughty little Prussian was not long in winning the goodwill and confidence of the Commander in Chief, his officers and men.

Washington saw in von Steuben exactly the right temperament and professional skills sorely needed to give his citizens' army the basic training and uniform drill it had lacked from its very beginning.

Steuben set to work immediately, with Hamilton as translator, preparing sets of drill regulations based on a simplification of the Prussian system. Training was begun in the deep snow and cold of Valley Forge, in units of one-hundred. Little attention was paid to the niceties. The Americans were trained to a prescribed marching step halfway between quick and slow time—an easy and natural gait for the men and the terrain.

They were drilled, and drilled again, in the practical details of loading and firing, the use of the bayonet in which they were notoriously weak, and to the precise execution of essential foot movements.

The old straggling line of march which cost the Continentals so dearly as far back as Brooklyn Heights and as recently as Brandywine, were soon to be gone forever.

Whether von Steuben was a Baron or was not is a matter of scant importance. He was a providential gift at what surely was a low point in the morale, efficiency and esprit of Washington's hard-pressed army.

Martha Washington, ever the good soldier, arrived at Valley Forge in early January. Lucy Knox and Kitty Greene arrived a few days later. They brought some cheer to the cold, snowy camp and its grim hospital cabins.

Soon a small wave of hospitality flowed from Washington's cramped headquarters in the commandeered house of a prosperous Pennsylvanian named Potts.

But it was feeble contrast, indeed, to the warm and relatively splendid days and nights Howe and his officers were spending in Philadelphia.

Francis Hopkinson, verse writer and flag-designer, summed it up in this taunting little verse:

"Sir William he, snug as a flea,
 Lay all this time a-snoring,
 Nor dreamed of harm, as he lay warm,
 In bed with Mrs. Loring."

Whether it was the lure of warmth and comfort, or a growing sense of the complexity of command in a strange and hostile country—something kept General Howe from doing as Washington had done just a year earlier at Trenton: Mount a strong surprise attack on Valley Forge.

As the critical year of 1778 opened, Washington's army, cold and ill-fed though it was, was largely intact. More important it was becoming a cohesive army, not simply a collection of disparate regiments of one-year "Continentals" and a variety of volunteer militia.

Steuben with his implacable drilling, Washington with his calm presence, and the events of the past year were slowly forging the first United States army.

Shortly after Washington's unsuccessful attack on Germantown, Count de Vergennes, France's Minister of Foreign Affairs, said in Paris: "Nothing has struck me so much as General Washington attacking and giving battle to General Howe's army. To bring troops, raised within a year, to do this, promises everything."

It was to be a strong omen of things to come.

1778—The Year
The War Widened

By 1778, after facing the armed might of Great Britain for more than two years and showing no signs of backing off, America had emerged as a sizable factor in Europe's balance-of-power politics—and was to remain so for the next 200 years.

Benjamin Franklin had been in Paris since December, 1776, leading a group of American Commissioners seeking the continued friendship and aid of France in the American cause.

Franklin himself had been lionized from the day he arrived. His studied plainness of clothes and manner, his air of a wise and patient philosopher—in short, his personal genius, opened the best houses, the best minds and the highest offices in Paris to his shrewd maneuvers in behalf of the American dream.

In Franklin's hands it was no mere dream, it was a tough, wily political fight where all tactics were good if they worked. The weight of Britain's diplomatic and intelligence forces were against him. The air was filled with rumors and plots and shifting allegiences. For it must not be forgotten that, to Britain, this was a civil war in which the role of some "Americans" was very shifty indeed. Espionage was rampant, from the subtle to the comic.

Franklin sought but one thing—help for American independence.

Within a few weeks of his arrival some practical help was quietly flowing. Major shipments of supplies, food, clothing and armaments began reaching the Colonies through the subterfuge of a French commercial firm, Hortalez and Cie. French ports were open to American privateers.

Much has been made, perhaps too much, of the intrigues and espionage of double-agents who flitted through these two years of politico-diplomatic maneuvering.

There is no doubt, however, about one curious and interesting figure: Edward Bancroft was an American physician from Springfield, Massachusetts. In 1776, he was living in London and was invited by Silas Deane to join the American group in Paris.

Bancroft, if he was not already a British agent, became one very quickly after he arrived in France. He was very close to Deane, a much less gregarious soul than

Franklin. Bancroft passed along to London, in weekly notes written in invisible ink, every move Deane made, every secret he had.

So good was Bancroft's cover that his role was not uncovered until half a century later, long after his death.

But Franklin's interest lay not in intrigue but in very subtle and shrewd use of France's national ambitions and her natural protective interest in thwarting the ambitions of Britain in Europe and in the world.

France's Louis XVI and his Foreign Minister Vergennes were keenly aware of the opportunity offered by George III's continued entanglement in an American conflict which refused to behave like a proper European war. For two years the British won the battles and Washington was winning the war. It was a costly game, politically and financially, and both London and Paris knew it.

In the Spring of 1778 two events occurred in London which made it clear that there were strong voices and forces in Britain beginning to ask if the time had not come for some decisive move, or some cutting of the losses.

First was a decision by Lord North to join Foreign Secretary Germain and others who thought Sir William Howe's usefulness as Commander in Chief in America had come to an end. In May, 1778, Howe was officially replaced by Sir Henry Clinton who took over command in Philadelphia.

It was to prove a trade of dubious value.

The second event was a bolder move of far greater significance. Lord North, obviously acting for the Crown, set about to convince Parliament that the time had come to cut British losses in America. He proposed a set of "Conciliatory Propositions" designed to bring military hostilities in America to an end.

Virtually every area of friction between Britain and the Colonies was to be wiped away—even the soupbone issue of "taxation without representation."

VALLEY FORGE
DECEMBER, 1777

In the cold, dreary snow von Stueben harangues a ragged group of soldiers. In left center Washington stands with a bundled-up Martha who "came down from Philadelphia for the day."

And it was cold, and gray and discouraging.

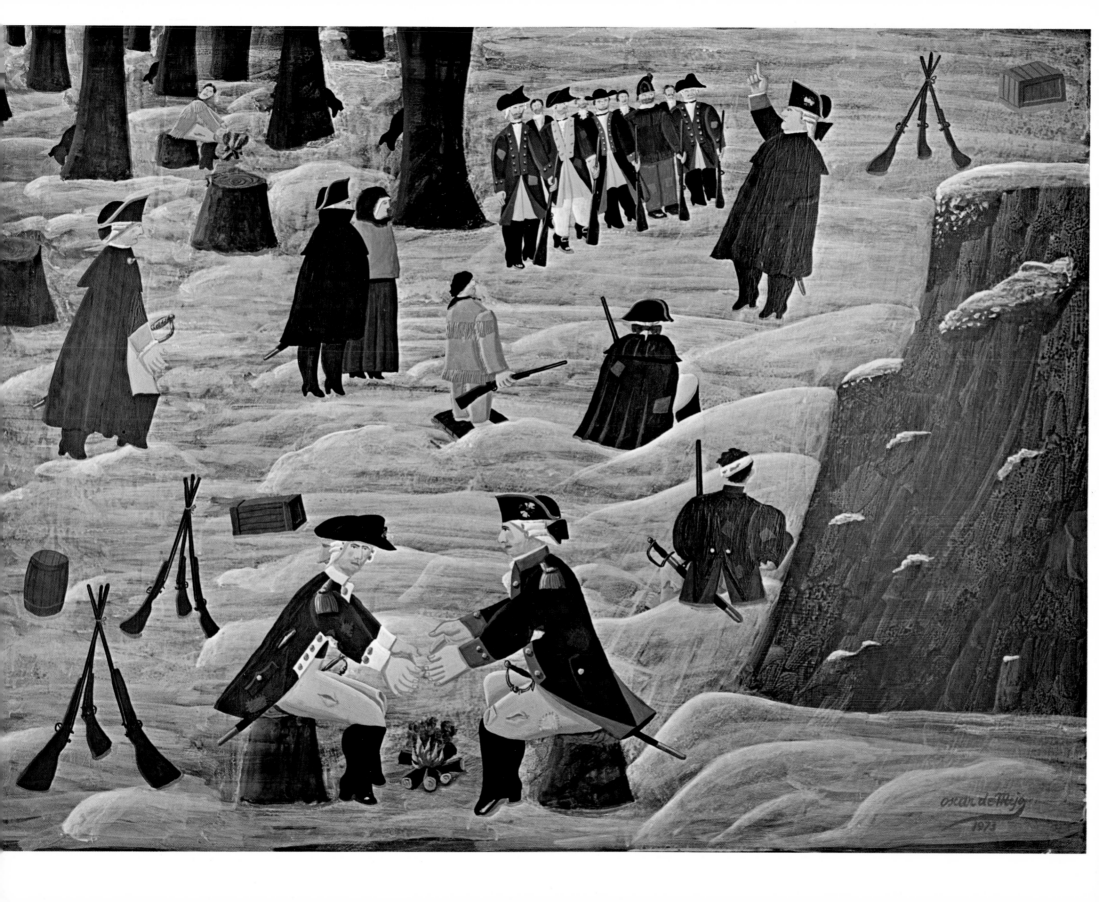

All, that is, except the heart of the matter:
Independence of America as a sovereign nation.

This last step North could not go.

As a matter of fact he had to use all his power, his guile and political clout to get the "Conciliatory Propositions" through Parliament. But the "Propositions" were passed, and they were to be submitted to the American Congress.

This was powerful leverage for Franklin in Paris. In his own shrewd manner he made it abundantly clear that Britain, rid of her costly and seemingly endless involvement in a war on the American Continent, would be free to move briskly and boldly in Europe.

Things began to move very rapidly toward a Treaty of Alliance between France and America.

The French agreement was actually secretly signed by Franklin and French Foreign Minister Vergennes in Paris on February 6, 1778. On that evening Franklin was said to have been uncharacteristically resplendent in figured blue velvet with white lace ruffles.

But on March 20, when Louis XVI received the American Commissioners in the full pomp and glory of Versailles, Franklin arrived in plain brown homespun, his hair "unclubbed" and his half-glasses perched on the end of his nose. But he signed with a great flourish. With Franklin were Silas Deane, Arthur Lee, Ralph Izard and William Lee—all splendid in full, formal court dress.

Lord North's "Conciliatory Propositions" reached the Continental Congress while Washington's troops were just emerging from the long Winter of Valley Forge. Sir Henry Clinton had just arrived in Philadelphia to take over command from Sir William Howe. In short, when the British military and naval position seemed strong on the American continent.

But Congress wasted little time in rejecting London's offer outright. It was to be Independence or nothing. Congress, in fact, added a rather sharp reminder that Britain "could not be trusted."

If there was any major American dissent from this flat-footed position it was quickly dispelled by the arrival on May 2 of the proposed French Treaty of Alliance.

Congress took just two days to accept the French Treaty which was formally ratified on May 4, 1778.

Essentially the Treaty called for a military alliance predicated on the fact that France and England would be at war—a condition virtually assured by the Treaty itself.

France guaranteed the Independence of America and promised to continue hostilities until that great goal was achieved.

America, for its part, agreed to two commitments:
Not to make a separate peace with Britain without French consent
America pledged itself to the defense of the French West Indies.

In June, 1778, France formally joined the war on the side of the Americans.

On the American military front things were beginning to stir again as the long Winter yielded to the Spring of 1778.

Clinton had barely taken over as Commander-in-Chief of British forces in America when the French alliance was signed.

On June 18, he made his move out of Philadelphia, across the Delaware on the start of an overland march to Sandy Hook in Jersey and from there the easy passage back into New York.

The Strange Battle Of Monmouth

Intelligence out of Philadelphia had been good and Washington, still at Valley Forge, knew Clinton's plans well in advance. He sensed a rare opportunity to deal a hard blow at an enemy force with its flanks exposed on a long, open march through unfriendly territory.

Washington, as he often did, called a Council of War. Charles Lee, technically second in command and not many months back from his captivity by the British, was full of doom and made it clear that he was "passionately opposed" to an attack on Clinton and his "superior troops."

In a second meeting Washington called first on Brigadier Anthony Wayne, who had been in the field almost constantly since 1775. Wayne's vote was instant and simple: "Fight, Sir!" Nathanael Greene, Hamilton and Cadwalder voted with Wayne, but they were a minority of four.

A week later Washington, acting on his own military instinct, decided to attack Clinton on his first march as British Commander in Chief.

Technically the field command of such an action should go to Lee but he, at first, scorned the assignment and Washington gave the job to Lafayette.

Only when the moody and brooding Lee discovered that the American force was to be a major one—6,000 men—did he petulantly demand the Command as his by right of rank. Unfortunately Washington yielded.

Lee's command of the golden opportunity at Monmouth Courthouse in New Jersey can only be described as a disastrous shamble of indecision and lack of vigorous leadership.

Anthony Wayne and his Pennsylvanians struck the first hard blows at the exposed British flanks. All it needed was a quick re-enforcement and strong pressure to cut Clinton's army in two. But the help never came and Clinton turned on his own pressure.

Dragoons and crack Guard troops tore into action and

began scattering the confused and leaderless American troops. Lee, in panic, called a retreat.

At this point Washington himself roared into the turmoil, cursed Lee out in language that wilted crops for three counties around and ordered him to the rear.

But the golden moment was gone, the Battle of Monmouth, a maddening debacle in the hot Summer sun, frayed out in a no-decision bout. The British managed to withdraw and continue on, eventually to New York and Staten Island.

As a matter of fact the most enduring thing to emerge from the shambles of the battle was the sturdy legend of Molly Pitcher.

In real life she was Mrs. Mary Ludwig Hayes, a formidable woman who ran more to bone and beef than to the subtler female charms. Her husband was manning an artillery piece at Monmouth.

Naturally the troops called her Molly Pitcher, for most of the long, steaming-hot day she toted water to the troops in a pitcher. When her husband collapsed from exhaustion and the heat of the day she took his place at the gun.

"Molly" has become something of a symbol for the hundreds of wives who followed the troops through most of the war—particularly in the North—often serving as scroungers of food, amateur nurses and toters of water.

The strange battle of Monmouth Court House marked the last major confrontation of the war in the Northern Colonies and the last time the American Commander-in-Chief and his British counterpart would meet in face-to-face battle.

After Monmouth, Lee engaged in a long and rancorous correspondence with Washington. Eventually he faced a court martial and was suspended from active command. Within the year his strange and highly suspicious career in the American army came to an end.

The French Arrive on the Scene

Tangible fruit of the French Alliance was not long in coming. On July 8, 1778, within a few days of Monmouth, a strong French fleet appeared off the Delaware Capes—twelve ships of the line and four frigates. On board were 834 heavy guns and 4,000 soldiers. The force was under the command of Admiral Count Charles Henri d'Estaing.

d'Estaing headed his fleet toward Sandy Hook, from where he could sight Admiral Richard Howe's British fleet near the Jersey shore. Howe's command included only nine ships and some 500 guns. All d'Estaing had to do was get across the bar extending from Staten Island to the Hook.

It proved to be literally impossible. The French ships simply drew too much water to risk it. For more than a week he lay there. Washington sent Alexander Hamilton as his envoy to d'Estaing—who showed a considerable zeal to get into action. He had one major problem: His orders limited his stay in North American waters. Paris was itchy about its West Indies islands and wanted its fleet down there as soon as possible to see that they were held secure.

But there was time for one major move. A swift land and sea assault on British-held Newport, Rhode Island, was agreed upon and plans hastily drawn.

Late in July the French fleet closed in on Newport. American land forces under the luckless John Sullivan moved south out of Providence toward Newport.

Very shortly the whole hasty plan began to come unglued.

Sullivan disagreed violently with d'Estaing about how to use combined French and American troops. While the debate went on a strong British fleet under Admiral Howe was sighted up the Sound. d'Estaing hastily reloaded his troops and set out for action at sea.

Before the naval battle could be joined a storm of hurricane force swept in, scattered and badly mauled the two fleets.

Abandoned on shore Sullivan had little choice but to fight his way clear and get out as fast as he could, cussing and screaming all the way.

When the storm passed d'Estaing was badly in need of repairs and headed for Boston, the nearest port that could make him whole. When he was again seaworthy d'Estaing was under orders to head South to Martinique with his 4,000 troops.

There was a rather snarling sequel to France's first unsuccessful involvement in the American war.

Expectations had been high for an "Allied" victory at Newport. When it frayed out in a confused kind of failure, disappointment ran high and d'Estaing was tagged with much of the blame.

Sullivan blasted him. d'Estaing, no purring pussycat himself, hit back at the "confused, incompetent Colonial command."

Washington, ever the patient soul, smoothed the ruffled egos and persuaded Congress to pass a resolution welcoming and commending d'Estaing and his forces. Washington knew full well how important it was to have an active alliance with France, the second most powerful nation in the world.

Newport taught its own long-term lesson. It was the first time, but by no means the last, that American Officers learned the hard way that Allied commands are not the easiest things in the world to manage successfully.

d'Estaing was to appear in one more American engagement, the sorry story of Savannah in the Fall of 1779. All in all, he could not have been very happy about his American service, important as it was.

Count Charles Henri d'Estaing—a distant cousin of today's President of France, Giscard d'Estaing—was not destined for a hero's role in battle. He died by the guillotine in 1794 during the French Revolution.

When the flurry of frayed nerves after Newport was ended, Washington moved his Army from Haver-

straw Bay to King's Ferry and then on up to White Plains.

The American Commander-in-Chief could be pardoned for a strange sense of accomplishment. Just two years ago he had fled to White Plains in retreat from the debacle on Long Island. His enemies were on the offensive and pressing him hard.

Two years later the American army and its Commander-in-Chief were still in the field and had freedom of movement while his powerful adversary, under new Command, was stalled in New York "reduced to the pick and the spade for defense."

More important: In the Summer of 1778 Washington's army was at its peak of strength. In July nearly 17,000 rank and file were reported fit for duty. About 12,000 of these were in White Plains.

October brought more cheering news. A large shipment of food, uniforms and shoes had arrived from France. For the first time American forces could be turned out in something resembling uniform dress.

In November the army went into Winter quarters—this time not huddled together for warmth but separated in strategic locations: at Middlebrook, Elizabeth and Ramapo in New Jersey; at West Point and Fishkill in New York; at Danbury in Connecticut.

Washington had, in fact, created a semicircular pattern of camps each about 40 miles or less from New York City. He could keep Clinton bottled up, and cut off easy travel and communications between the British and the New England colonies.

Once more the American troops were sheltered in log cabins and were moderately comfortable in a mild and easy Winter.

Money, not Clinton, was the big problem in the Winter of 1778. Not a scarcity of money, there was plenty of it, barrels of it in fact—all Continental paper. There was so much of it that it was virtually without value. By the Spring of 1779 Washington wrote to a friend

in Virginia: "A wagon load of money will scarcely buy a wagon load of provisions."

But, taking one thing with another, Washington's American army was a powerful reality and a thorn in the side of British prestige.

And now Washington had a powerful ally—the might of France.

Anthony Wayne and Stony Point

The late Winter of 1778 and the Spring of 1779 were strangely quiet. Both Clinton and Washington were content to keep their forces at ease in Winter Quarters until Spring was well advanced.

Clinton made the first move and it was a classic one. From the earliest days of the war the British, facing a foe with no naval force, saw the Hudson River as a wide open opportunity to "split the Colonies in two."

On paper maybe, but in a practical military sense the idea was little more than a vague theory. The Hudson is no mere stream. The water and land forces necessary to keep it shut off altogether to Colonial traffic would be enormously costly.

But Washington had always been wary of any strong move up the Hudson because of the threat it posed to West Point which he regarded as essential to the American cause.

Clinton's plan was utterly simple and practical.

On May 30, with a fleet of seventy sailing vessels and more than a hundred flat-boats, he embarked 6,000 troops from Kingsbridge. The force was of top quality: British and Hessian Grenadiers, light infantry and Tory regiments including Simcoe's Rangers.

On June 1, they landed on both sides of the Hudson scarcely 35 miles north of Manhattan. Their goals: Verplanck's Point on the East shore of the Hudson, topped by Fort Lafayette manned by about 70 North Carolina troops. The ranking officer in the fort was a Captain.

On the West bank of the Hudson the attack was aimed

at Stony Point, recently occupied by a handful of American troops.

The British found scant opposition to their strong attack force. At Stony Point the few Americans abandoned the position without a fight against such lop-sided odds. They burned the blockhouse and got out fast.

The British promptly mounted artillery on Stony Point and began a heavy cannonading of Fort Lafayette, directly across the river on Verplanck's Point.

It was all over very quickly. The British immediately invested Fort Lafayette which, though small, was a complete and well protected strong point. They also set about rebuilding and completing proper fortifications at Stony Point.

Often called the "Gibraltar of the Hudson," Stony Point is a rugged rock promontory thrusting half a mile out into the river and rising about 150 feet above the water.

At its West, or inland side, it was separated from the firm mainland by a swampy marsh curving around the Point in a rough semi-circle from its northern to its southern edge. The only "dry" crossing was by means of a bridge and a rough causeway leading to a road which ran to the King's Ferry landing on the northern shore of the Point.

For all practical military purposes Stony Point was an island—the Hudson on the East, a curving swamp, often hip-deep, on the West.

After walking into Stony Point without firing a shot, Clinton set his engineers to building a proper, well protected fortress.

On its highest elevation, commanding the Hudson and the New York shoreline, he installed eight batteries of guns connected by trenches. Immediately to the West, high on the rocky slope, he built a semicircular abatis—a protective ring of felled trees placed with their thick branches facing west toward the main-

land. Further down the slope were smaller gun emplacements surrounded by a second semi-circular, protective abatis.

A garrison of about 600 men was established including Fraser's Highlanders, a body of Tory Americans and a corps of artillerymen, all under the command of Lt. Colonel Henry Johnson.

The whole tidy project was completed in less than three weeks.

Washington was deeply concerned about the loss of two strong points on the Hudson. At first he saw no way out: "All we can do is lament what we have not the force to remedy." But he did move to protect West Point by shifting a major part of his army to Smith's Cove, about midway between West Point and Stony Point.

Within a week he was in a more aggressive mood, and he turned to a man who fit that mood, Brigadier General Anthony Wayne who had been on leave at his home about 20 miles from Philadelphia.

By June 27, Wayne was at Fort Montgomery on the Hudson, formally vested with command of an elite American army corps—the Light Infantry, as yet only partially organized.

On July 1, Wayne received another written order from Washington: "This you will consider as private and confidential. The importance of the two posts of Verplanck's and Stony Point to the enemy is too obvious to need explanation. We ought, if possible, to dispossess them. I recommend to your particular attention without delay to gain as exact a knowledge as you can of the number of the garrisons, the state of the creeks that surround them, the position and strength of the fortifications . . .

"It is a matter I have much at heart to make some attempt upon these posts . . . I shall thank you for your opinion of the practicability of a surprise of one or both of those places—especially that on the West side of the river."

On July 3, Wayne reported to Washington that he had reconnoitred Stony Point and its approaches. He sent Washington a sketch of the general layout and invited Washington himself to have a look under the protective screen of Wayne's troops—an offer which Washington accepted and personally looked over the vicinity on July 6.

The Light Infantry, a special mobile attack force which Wayne had urged upon Washington for more than a year, was less than a month old. It consisted of four regiments.

The total force numbered about 1,300 men of all ranks.

On the morning of July 15, 1779, Wayne's force gathered at Sandy Beach, South of West Point—"fresh shaved and well powdered." By noon they were on the march over 13 miles of bad roads, rugged mountains and narrow passes often strung out in single file in the Summer sun.

It was eight o'clock in the evening when the long, hot march brought them within two miles of Stony Point. Here, hidden from the Fort by high ground, they heard from General Wayne, for the first time, what their night's work was to be and how it was to be carried out.

The word was simple and bold.

The fort was to be stormed in the darkness of midnight. The strong British defense was to be smashed by the bayonet alone. This night needed absolute discipline, absolute silence and strict adherence to a detailed and daring plan.

The Order of Battle was simple enough, consisting of two major, three-tiered forces. On the right, or South slope of the Point was the First Regiment under Col. Christian Febiger to be followed by Hull's battalion and the Third Regiment under Col. Meigs. Preceding this force were 150 "chosen and determined men" led by Lt. Col. Francois Fleury, a distinguished French soldier.

Fleury, in turn, was to be preceded by a "forlorn hope"—in today's parlance a "suicide squad" of twenty men led by Lt. George Knox, whose task was to chop openings in the protective abatis and pour through so that Fleury's troops could follow, scatter the defense with hand-to-hand bayonet attack and open the way for Febiger's main body.

On the left, or North Slope, a similar attack plan: The "forlorn hope" out in front led by Lt. James Gibbons; a 150-man first-strike force under Major John Stewart of Maryland opening the way for the Second Regiment and Murfree's Battalion. The total force on the left column was in command of Col. Richard Butler of Pennsylvania.

Wayne himself was with Febiger on the right wing.

All muskets in both main columns were armed only with the blade of a bayonet. Murfree's battalion alone had loaded muskets. As the two columns moved up hill, Murfree's battalion was to expand to its right, in the opening between the two main forces. They were in fact to be used as decoys. On signal they were to provide a brisk musket fire as though the main attack was coming from the center.

It was a bold plan demanding prompt and precise action from a Corps which had been together scarcely three weeks.

At eleven-thirty they were ready. Each man placed a piece of white paper on his hat for easy identification in the dark. Wayne's order was blunt and tough:

"If any soldier presumes to take his musket from his shoulder or attempt to fire or begin the battle until ordered by his proper officer he shall be instantly put to death by the officer next to him, for the misconduct of one man is not to put the whole troop in danger of disorder.

"After the troops begin to advance to the works, the strictest silence must be observed and the closest attention paid to the commands of Officers."

33

Wayne had learned well at Chad's Ford, at Paoli, at Germantown and Monmouth—in fact, as early as 1775 when he had to retreat from three rivers after the debacle of the American adventure into Canada.

He also knew that battles were won by something more than iron-handed discipline:

"The General has the fullest confidence in the bravery and fortitude of the Corps that he has the happiness to command—the distinguished honor conferred on every Officer and Soldier who has been drafted into this Corps by His Excellency General Washington—the credit of the States they respectively belong to and their own reputations will be such powerful motives for each man to distinguish himself that the General cannot have the least doubt of total victory—and he hereby most solemnly engages to reward the first man who enters the Fort with $500 and immediate promotion; to the second $400, to the third $300, to the Fourth $200 and to the fifth $100.

"But should there be any soldier so lost to every feeling of Honor as to attempt to retreat one single foot or skulk in the face of danger, the Officer next to him is immediately to put him to death—that he may no longer disgrace the name of a Soldier or the Corps or State he belongs to."

There was one other order: Once inside the Fort, and not a minute before, each man was to shout, and keep shouting "The Fort is Our Own!"

For the first time Wayne had his own plan, his own Corps, his own enemy and his own vivid target waiting in the darkness.

Brigadier Anthony Wayne, 34 years old, in the service of the American war since 1775, was at the peak of his powers and he felt it to his fingertips.

The main attack was to be made on the South front, by the stronger right wing, with Wayne in the thick of it.

Shortly after 11:30 p.m. the two columns moved forward. The right column tried to skirt the edge of the swamp but was soon hip-high in muddy water. But the ranks stayed close and pushed on. British pickets soon discovered the movement and opened fire.

The Corps pressed forward as briskly and as silently as the rough going allowed. Soon the axes of the "Forlorn Hope" made openings in the abatis. Fleury and his strike force struggled through and scrambled up the rocky slope, now alive with British gunfire. Wayne was hit and suffered a flesh wound in the head. He revived fast and continued to direct the attack.

On the left Butler's column was doing equally well although both he and Col. Hay were slightly wounded.

At the first sound of the axe blows Murfree's men had filtered into the gap between the advancing columns and begun their diversionary fire.

The right column reached the fort first. Fleury was the first man to scramble inside where he promptly tore down the British regimental flag. The next four men inside were Lt. George Knox, leader of Fleury's "Forlorn Hope"; Sergeant Baker, a Virginian, already hit four times; two Sergeants, Spencer of Virginia and Dunlop of Pennsylvania.

Up went the battle cry—"The Fort is Our Own!"

Inside the fort was turmoil. Col. Johnston, the Commandant had taken the bait of Murfree's musket fire and hurried out of the fort with six companies, headed down the slope to meet what he thought was the main attack. The defense was left without a coherent command.

Now Colonel Butler poured in from the left, driving the confused British into the hands of Febiger's troops on the right.

The defense was totally disheveled and cries for "Quarter!" were mixed with the growing, cocky chant of the American war cry.

WAYNE AT STONY POINT
JULY, 1779

Again the female figure, etherealized in the dark night, watches over Wayne and his Legions as they move through the night to a smashing victory under a sickle moon.

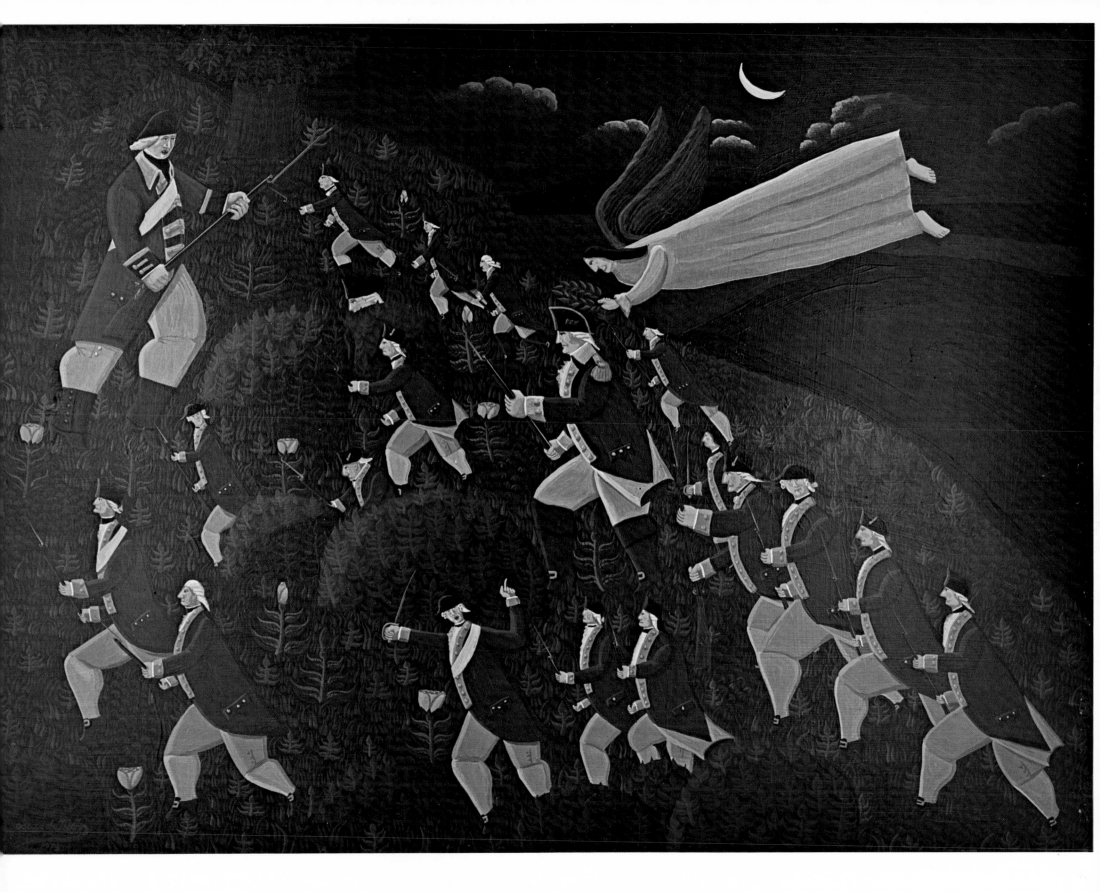

In the midst of it all Col. Johnston, trying to scramble back up the hill to the fort, was captured by Febiger.

The British forces which had stayed in the fort had fought as well as they could but the momentum and precision of the American attack was too strong a tide. In less than an hour Stony Point was won.

British losses in the brief struggle were high: 63 killed, nearly 80 wounded and 543 taken prisoner.

At 2:00 a.m., when all had been secured, Anthony Wayne sent off a three line dispatch to General Washington:

The Fort and Garrison with Colonel Johnston are ours. Our Officers and men behaved like men who are determined to be free.

Yrs. Most Sincerely
Anthony Wayne

No time was lost in turning the British artillery on Fort Lafayette atop Verplanck's Point just across the river. There was no return fire, only silence. The American gunners then had a go at the British sloops at anchor below the Fort. After a few rounds they slipped anchor and sailed away on the ebb tide.

The Ordnance and Stores which were captured in the swift victory were appraised at a total of $180,640. The total, in keeping with Wayne's agreement before the attack, was distributed among his troops in proportion to the pay of officers and men. Each Private soldier's share came to $78.92.

Wayne also delivered promptly on his "Bonus" offer to the first five men to enter the Fort. Colonel Fleury, who was entitled to $500 and "immediate promotion," accepted the money but declined promotion "if it meant leaving Wayne's Light Infantry Corps."

Lieutenant Knox got his $400. Sergeants Baker, Spencer and Dunlop $300, $200 and $100.

Stony Point was a singular and much heralded triumph—out of all proportion to its actual military value.

Suddenly there was a new view of Washington's army: American troops were now "professional" enough to carry out a bold, precise plan of battle with efficiency and skill. They had shown themselves confident enough of their Command and of themselves to take the offensive and win against the very best of British troops armed to the teeth and protected within a very formidable fortress.

Stony Point did very little for the war itself but it was a superb and timely boost for the Revolution.

One satisfying aspect of the victory was the recognition, by friend and foe alike, of the restraint and clemency shown by Wayne's Corps toward their beaten and vulnerable foes.

British Commodore George Collier later wrote: "The laws of war give the assailant a right of putting to death all who are found in arms. The rebels had made the attack with a bravery never before exhibited and they showed at this moment a generosity and clemency which, during the rebellion, had no parallel."

For Brigadier Anthony Wayne it was a sweet and total triumph. He could almost forget the bloody night of "massacre" at Paoli less than two years ago.

Stony Point was pure glory.

Congress voted Wayne a gold medal and a resounding resolution.

More important, Washington thanked him warmly and commended him publicly with more than ordinary spirit.

Stony Point had one other advantage which has always added visibility to the world's successful battles —it was fought close enough to the nerve center of the Colonies to get considerable press coverage. Philadelphia papers had the story as early as July 16 and within the next three weeks the dramatic news of victory at Stony Point was printed in paper—Tory as well as Rebel—from New York to Boston and New Hampshire.

For all its impact, and in spite of the way it has remained vivid in the history of the War for Independence, the American presence at Stony Point was as fleeting as a Summer dawn.

Within days of the victory Washington inspected the captured Fort and decided it was not practical to maintain an American force atop Stony Point. It would require more troops than he could afford. He ordered the removal of its guns and the destruction of defensive fortifications.

General Clinton promptly re-occupied the Point, built stronger fortifications and installed new troops who were in possession virtually to the end of the war.

In the calm that followed the success at Stony Point in the Summer of 1779, Captain Allan McLane, who had been Wayne's spy in ferreting out the details of Stony Point's fortifications, had been using his Cavalry Company as rangers scouting the countryside deep into New Jersey and feeding information into Major Henry Lee's headquarters at Paramus.

"Light Horse Harry" Lee, a hell-for-leather 22-year-old Cavalry Major, had an eye for the center of action and was impressed by Wayne's highly visible success at Stony Point.

Based on reports he received from McLane, Lee believed the British fortifications at Paulus Hook offered another opportunity for a hit-and-run attack similar to Wayne's.

As a fellow Virginia squire, though young enough to be Washington's son, he had access to the Commander-in-Chief and after a somewhat cool reception did manage to convince Washington that one more quick victory could do no harm.

Paulus Hook was a low, rather dank point of land on the West bank of the Hudson River on the edge of what is now Jersey City. It was partially isolated from the mainland by a creek and deep ditches crossed by a single guarded draw-bridge. The fort on the Point was further guarded by two rows of abatis and earthwork barriers.

Within the fort were heavy artillery pieces and a garrison force of British foot soldiers, Tory troops and

light infantry. The fort also contained a small infirmary.

Lee's battle plan was virtually a carbon copy of Wayne's Stony Point assault—the attack to be led by "Forlorn Hope" squads; the attack force to move in three columns; the assault to be carried out by bayonet alone.

There were but two points of difference: The attack force itself was only about a third as big as Wayne's, about 400 men all told.

Muskets were to be loaded but not primed.

Except for several hours wasted getting lost in a dense woods, which delayed the attack until four a.m. on the 19th of August, the plan worked well.

The British garrison offered little resistance and within an hour Lee was the victor. Not one American shot was fired. Fifty British were killed by bayonet, 158 surrendered. Lee lost only two dead and three wounded.

Paulus Hook was obviously too close to Clinton in New York to be held by the Americans—the idea was simply to win, capture, destroy and get away fast before the British cut off the lines of retreat.

As a matter of fact "Light Horse Harry" needed all his luck and guile to get away. Lord Stirling was supposed to meet him with get-away boats at New Bridge but something went awry and neither Stirling nor the boats were there. Tories began to harry Lee's flanks but enough re-enforcements showed up for Lee to fight his way out successfully.

Once more the country-side joined in praise of a new victory and a new hero. Congress voted its thanks, a medal and 15,000 nearly worthless Continental dollars to "Light Horse Harry" Lee who had his hour in the sun. Lee's greater contribution to American military history was to come many years later through his son, Robert E. Lee.

The slashing success at Paulus Hook was the last blow struck by Washington's army in 1779. The late Autumn months were spent in strengthening the fortifications at West Point.

Cornwallis arrived in New York from London late in 1779, with fresh troops for Clinton, bringing him to a strength close to 28,000.

Washington, in theory, had only a few thousand fewer men, but the hard fact was that only about 15,000 of them were enlisted for three years or more. The rest would melt away at the end of the year.

The One and Only John Paul Jones

Of all the singular characters from odd corners of America and Europe who were swept up by the Revolution none was more driven by a hunger for action than the mercurial man of the sea we know as John Paul Jones.

His true name was John Paul, son of a Scottish landscape gardener who apprenticed the boy to a merchant shipper when the lad was twelve years old.

From that minute on, John Paul was on his own tumultuous course.

Before he was 18, he was Chief Mate on a ship out of Jamaica plying the slave trade. Two years of that and he decided to return briefly to Scotland. The ship he sailed out of Jamaica was fever ridden and before the voyage was a third completed, both the Master of the vessel and his chief mate died. John Paul became acting Master and brought the ship home.

He lived to regret returning to Scotland for he was promptly arrested and charged with murder in the death of a ship's carpenter he had flogged for laziness a year earlier. John Paul was to curse that "outrage" for most of his life.

Somehow he was able two years later to acquire a ship of his own and traded in and out of the island of Tobago. In 1773, somewhere in the West Indies, he faced a mutinous crew and once more took drastic action in which the ringleader was killed.

John Paul promptly abandoned his own ship, changed his name to John Paul Jones and fled Tobago.

For about a year he dropped out of sight and then turned up following the death of a brother who was a tailor in Fredericksburg, Virginia, John Paul Jones shared in the estate.

Jones remained in America and in 1775, on the advice of Joseph Hewes, a member of Congress from North Carolina, he went to Philadelphia to present himself to Esek Hopkins who had been appointed by Congress to command an American Navy. Before the year was out John Paul Jones had been commissioned a Senior Lieutenant in Hopkins' tiny naval force.

Jones served on the "Alfred" which was to go into the Bahamas, an area young Jones knew well. He was serving on the "Alfred" during one of the earliest of America's naval victories, the capture of New Providence in the Bahamas late in 1775. The following year Jones was given command of the ship.

In June, 1777, back in Philadelphia, Jones was given command of a new ship the "Ranger" which was still under construction in Boston. The vessel was not finished until November when Jones and his crew took off for France—bursting with the news of Burgoyne's surrender and keyed up for a direct assignment of consequence.

John Paul Jones, just 29 years of age, was deflated when he arrived in France to discover that the news of Burgoyne had preceded him by weeks and that there was no formal command for him to take.

About the time of his thirtieth birthday, Jones wangled permission to cruise the "Ranger" in European waters—hit and run—in search of "prizes." He cruised with a vengeance.

Before dawn on April 23, 1778, John Paul Jones and 31 volunteers became the only American force to carry the Revolution to the very soil of England.

They went ashore at Whitehaven, an Irish Sea port just south of Solway Firth on England's northwest coast. They spiked the cannons in two forts and tried but failed to burn British vessels in port.

At noon the same day they took dead aim on Lord Selkirk, in residence on St. Mary's Island in Solway Firth. They missed his Lordship but scooped up all of Selkirk's prize silver. Jones later returned the loot, with warm apologies, to Lady Selkirk.

The following day Jones and his Ranger took on the British ship "Drake" and gave it a sound beating. Jones lost eight men, the Drake lost 42.

When John Paul Jones and Ranger returned to Brest he was hailed as a genuine hero. Nothing was too good for him, he was promised command of a fleet. But like many speeches, there was plenty of sound and fury, but no fleet materialized.

Jones' victories in ship-to-ship combat were not brought off by bravado and daring alone. He was something of an innovator. For one thing Jones was the first, perhaps the only, Commander to use seamen armed with muskets high up in the rigging so they could fire directly down onto enemy ships locked in close combat. It was an effective and deadly maneuver.

It was Summer of 1779, before Jones had anything resembling a "fleet"—four vessels of dubious ancestry.

The lead ship, under Jones' personal command, was an old re-fitted French vessel carrying 42 guns which Jones named "Bonhomme Richard" in honor of Franklin's "Poor Richard."

The other three were: "Alliance" a medium sized French ship; "Vengeance" and "Pallas" which were smaller and only lightly armed. Peter Landais, a French naval officer commanded "Alliance"—and would live to regret it.

On September 23, 1779, off Scarborough, England, on the return leg of another hit-and-run cruise which actually circumnavigated the British Isles, Jones and

CAPTAIN PEARSON
SURRENDERS
SEPTEMBER, 1779

"Surrender that sword," says the firm "Hand of God" as John Paul Jones, the sturdy hero stands proudly on the littered deck of "Bonhomme Richard." Standing off at sea, the "Spirit of Liberty" rises again in victory!

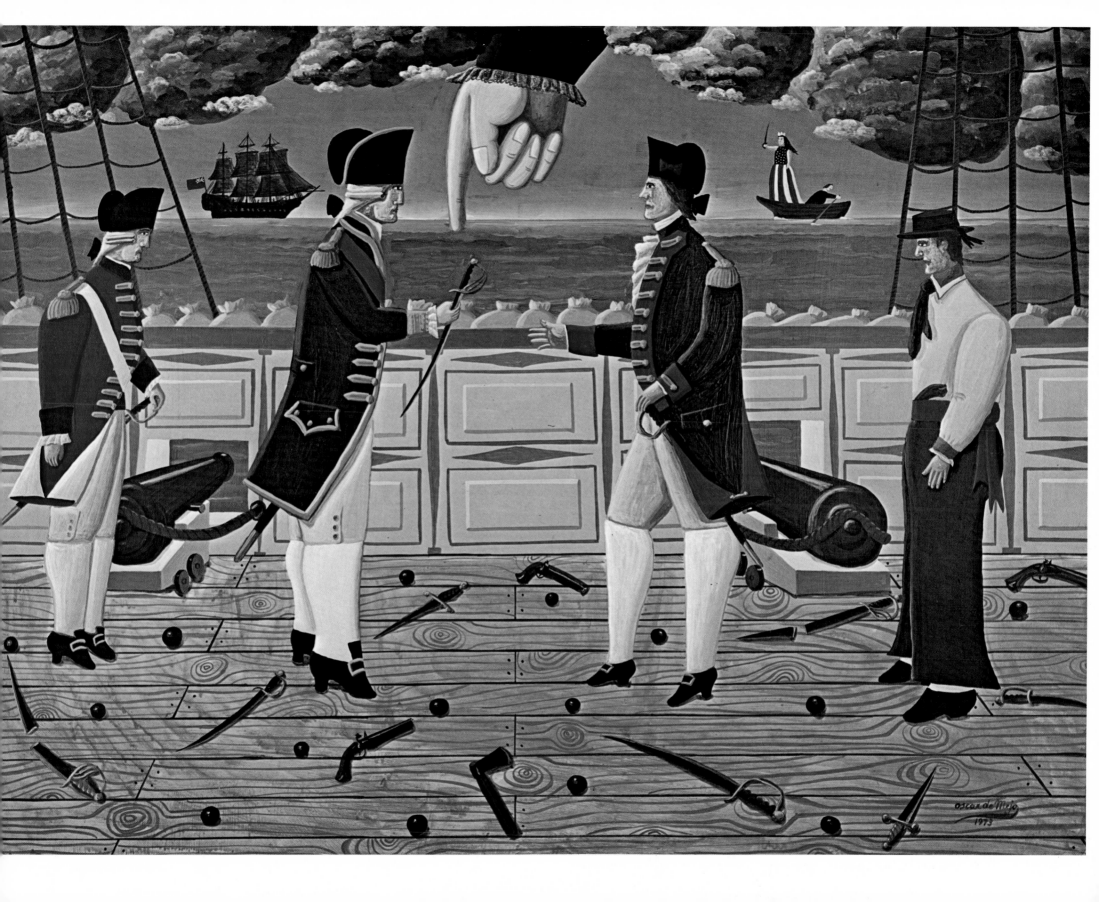

his mini-fleet came across a sizeable Baltic merchant fleet being escorted by the British ships "Serapis" and "Countess of Scarborough."

There was no way John Paul Jones could stay away from this tempting target.

Biding his time he chose to engage Serapis by moonlight. For three and a half hours Bonhomme Richard and Serapis were locked in a fight to the death—yardarm to yardarm. Whether or not Jones actually said "I have only begun to fight!"—he fought that way. Both ships were battered and bleeding in head-to-head combat.

Meanwhile Landais and his ship "Alliance" were a great help—Landais kept circling the two clinching fighters, firing indiscriminately into both ships!

At about four o'clock in the morning Captain Richard Pearson on the blazing Serapis, her main-mast gone, finally called "Quarter." The Bonhomme Richard was showing her age, frailties and wounds of the day —she was, in fact, actually sinking and had to be scuttled the next day.

Jones took over command of Alliance and filed angry charges against the ill-starred Landais.

Neither Pearson nor Jones ever issued casualty lists of their deadly duel, but after it was all over Jones had this to say:

"No action before was ever so bloody, so severe, so lasting."

Probably no single battle of two navel vessels ever made one man's name so famous for so long as this one did for John Paul Jones.

The rest of his Revolutionary War service was largely a series of frustrations for the restless Jones.

In 1788, he was still in France when Catherine the Great offered him a commission as a Rear Admiral in the Russian Imperial Navy. On the advice of Thomas

Jefferson, then American Ambassador to France, Jones accepted the offer.

Once again it was a case of large promises and skimpy delivery. John Paul Jones was offered Supreme Command of a Black Sea campaign against the Turks.

As might be expected, the "establishment" resisted him firmly.

The career Russian officers slighted him, maneuvered him and generally engaged him in one long, frustrating wrangle. Catherine the Great was, of course, far away and soon wearied of pleas from her hand-picked Rear Admiral.

So they finally got him.

In March 1789, John Paul Jones, a Rear Admiral in the Russian Imperial Navy, was brought to the bar on trumped up charges of criminal assault on a young girl.

Catherine the Great was at least great enough to turn him loose. He returned to France bitter and physically broken.

On Friday, July 18, 1792, John Paul Jones alone and unknown, died in Paris just twelve days after his forty-fifth birthday. He was buried in an unmarked grave in the St. Louis Protestant Cemetery.

More than a century later, through the efforts of another American Ambassador to France, Horace Porter, Jones' body was found and identified.

So John Paul Jones, at long last, was returned to the country for whose existence he fought. He was brought back with an escort of United States warships and now rests in a crypt in the U.S. Naval Academy at Annapolis.

The resting place of John Paul—Alias John Paul Jones—is now a National Shrine.

Hardest Winter of the War— 1779-80

Through the late Fall of 1779, Washington continued to hope that some offensive action might be taken with a combined French-American force. Count d'Estaing's

fleet had, on its return from Martinique, engaged in a losing effort to lay siege to Savannah. When that failed d'Estaing did not move North, instead he split his fleet. Part of the force returned to Martinique the balance, under d'Estaing's personal command, sailed home to France.

By this time it was November and Washington had little choice but to move into Winter quarters. The site chosen for the main body of the army was again Morristown, New Jersey.

Winter came hard and early that year and the armies had miles to march over horrid roads in freezing rain and blizzards of snow.

The 19th century historian, Henry B. Dawson, in his two volumes on "Battles of the United States," puts it this way:

"Though Valley Forge is fixed firm in the popular imagination, it deserves forgetfulness in comparison with the second stay at Morristown.

"Very early that Winter the cold came. And such cold! There had been nothing like it in the memory of the oldest inhabitant. Roads disappeared under four feet of snow. New York harbor froze over."

The cold, the deep and drifted snow made everything agonizingly difficult. Log houses went up with painful slowness. In January, men were still huddled in thread-bare tents. Lack of food was a serious, seemingly endless problem. In the middle of December Washington wrote:

"We have never experienced a like extremity at any period of the war . . . unless some extraordinary exertions are made there is every appearance that the army will infallibly disband within a fortnight."

An appeal to the Congress and to the Committees, then as now, was much like an appeal to the cold and driving winds. An echo came back, but very little real help.

In the end it was, as it usually was, up to the patient, strong-willed Washington to work out some solution.

He adopted a hard-nosed program of requisitioning. He divided New Jersey into eleven districts and for each of them he fixed quotas of grain and cattle—and then authorized an Officer for each district to go and get it by whatever means necessary.

The provisions thus seized were to be paid for sometime, somehow and a strict accounting was kept.

The system worked. Washington was able to say that the people of New Jersey "exerted themselves for the army in a manner that did them the highest honor." But a young, cold and hungry army has an enormous appetite and by March the cry for relief was heard again.

Actually the problem was not so much the lack of grain or meat as it was the dismal lack of money to buy it with—money that had any real value.

By 1780, Continental paper money was virtually useless. A night's lodging for five people cost $850. A few months later it took $500 to buy a decent pair of boots. An ordinary horse cost as much as $25,000.

It was a low point, indeed, for those who stayed to fight the battle.

And there were those who did not, who slipped away in the night. And there were those who mutinied. The soldiers of the Pennsylvania Line, for example, who had enlisted "For three years or during the war" decided to interpret this phrase as meaning whichever came first. Since three years had expired they claimed their freedom.

A settlement could have been reached with little trouble if the soldier's life, tough enough at best, had not been further plagued by cold and hunger, miserable clothing and no pay.

As it turned out, six regiments marched in good order out of Morristown headed for Philadelphia. The units were part of an army Division commanded by St. Clair and Lafayette. The mutinous troops ordered both of them out of camp and announced they would deal only with Wayne, Stewart and Butler.

At the urging of Washington and Wayne, Joseph Reed, President of Congress, with a committee of its members went to Princeton where the regiments had camped and managed to negotiate a settlement—largely on the soldiers' terms.

But the hard fact was: There had been mutiny, and nothing can be more dangerously contagious.

Treason Of A Hero

Benedict Arnold was the kind of man who had no friends—only loyalists or enemies. He lived most of his life in the very eye of the storm. On the few occasions when there was no storm he provided one of instant intensity.

Arnold was born in Norwich, Connecticut, in 1741, the only son of Benedict and Hannah Arnold to live to adulthood. In his early youth he was apprenticed to a pharmacist and in 1761, opened his own store in New Haven. In 1767, he married Margaret Mansfield whose father was Sheriff of New Haven. The Arnolds had three sons.

Arnold could stand his New Haven drug store just so long. For four years beginning in 1769, he got about as far away as he could—he acquired a sloop and sailed off to be a West Indies trader. The records of Arnold the trader are sparse but he seems to have dealt in horses and was not above whatever lucrative smuggling came his way.

Revolution and upheaval was his natural state and he was hip-high in Connecticut's revolutionary plotting as early as 1774. The following year he was elected Captain of the New Haven Foot Guards, a militia unit. Within a few months he was also commissioned a Colonel by the Massachusetts Committee of Safety.

In the Spring of 1775, Benedict Arnold went to war and was to remain there, one way or another, for most of his life.

Massachusetts had authorized Colonel Arnold to raise a force not to exceed 400 men to march on Fort Ticonderoga and wrest it from the British. On the way to Lake Champlain Arnold learned that Ethan Allen and his Vermont "Green Mountain Boys" were also marching on Ticonderoga.

After some acrimony over who was in command, they joined forces and on the night of May 10, 1775, surprised the British garrison, captured the fort and its seventy-eight pieces of heavy artillery which were promptly dispatched to Boston.

Arnold surely regretted that it was Ethan Allen, not himself, who went charging down through history by identifying himself with "The Great Jehovah and the Continental Congress."

On his return to New Haven Arnold learned that his wife had died, leaving him with three young sons who were put under the care of his sister, Hannah.

Colonel Arnold had tasted a tiny piece of real war and was eager for more. In the late Fall of 1775, Washington decided to make a move against Canada. The main American force was to move North from Ticonderoga into Canada. As a diversion Washington sent 1,000 men from Boston under the command of Arnold, including a company of Virginia Riflemen under Daniel Morgan. They were to move from Maine, largely by rivers and portages to a point on the St. Lawrence River opposite Quebec, held by General Sir Guy Carleton.

The real jumping off point was Fort Western on the Kennebec River. Arnold estimated the journey would take 20 days. In fact, the march proved nearly impossible. It took a full forty-five days of man-killing struggle against rushing river currents, back-breaking portages through the roughest of country with every day growing colder and shorter. Food ran out. The exhausted, the sick and the weakest of the stragglers had to be sent back.

When Arnold's tiny army finally arrived opposite Quebec only 600 of the original 1,000 were left, looking more like half-starved animals than men.

Christopher Ward in his two-volume "The War of the Revolution" says this:

"Arnold's journey to Quebec is one of the most famous marches recorded in history. If it had resulted in the capture of that stronghold it would have been celebrated as a great triumph . . . for sustained courage, undaunted resolution and uncomplaining endurance those men who grimly persisted to the end deserved high honor and unstinted praise."

But it did not succeed.

Winter was upon them. General Richard Montgomery finally arrived from Ticonderoga in mid-December with 300 men. On December 30, Arnold and Montgomery with this tiny force of 900 attacked Quebec from two sides.

The attack came as no surprise to Carleton. Montgomery was killed by a cannon ball. Arnold was wounded in the left leg. Lieutenant Aaron Burr tried to rally the attacking force with no success. Daniel Morgan, the stalwart, took command and fought bitterly to force the attack but was finally simply driven out.

But Arnold was not ready to quit. He was carried outside the walls of Quebec where he pulled the survivors together and tried again to put Quebec under seige.

All through the Winter he badgered Congress for men, supplies and weapons. Congress ignored his petitions but made him a Brigadier General.

It was June, 1776, before Arnold gave up hope. He obtained supplies for his men—he was later accused of plundering the merchants of Montreal—and began his journey back home.

He was pursued by Carleton and Burgoyne and tried to build a flotilla to fight them off at Valcour's Island. It was a daring holding operation but Arnold and his tiny army had to make a getaway.

Thus did Benedict Arnold, even before the Declaration of Independence, burst on the scene as a bold and dashing hero—"The Hannibal of America."

When Congress, in February 1777, named five Major Generals, Arnold was passed by and was furious. His appointment came in May, but failed to include seniority in grade. Arnold threatened to resign but was soothed by Washington.

Three more major events were to mark Benedict Arnold's career in the American army.

The first came in the Fall of 1777, at Saratoga where bumbling old Horatio Gates was in command, facing the British army of General John Burgoyne.

Arnold sensed that Burgoyne was vulnerable. Ignoring the clucking concerns of Gates, Arnold led a vicious attack on Burgoyne's army at Freemans Farm. Arnold not only trounced Burgoyne, he mauled him badly, inflicting nearly 800 casualties.

Having won a critical battle, Arnold got embroiled in a bitter argument with Gates and tendered his resignation—but stayed in camp.

Two weeks later, resigned or not, he led another attack on Burgoyne's strong entrenched position at Bemis Heights and again defeated the best Burgoyne had. In the battle Arnold's horse was shot out from under him and his left leg, wounded at Quebec, was badly shattered.

Ten days after Bemis Heights Burgoyne surrendered his entire army. It was a pivotal victory of the entire war and it probably would not have happened without Arnold. Burgoyne thought so, and said so.

Arnold was to spend more than five restless months in an Albany army hospital before his leg was healed enough for him to travel by coach.

He reported to Washington at Valley Forge on May 20, 1778, just as Howe was leaving Philadelphia for London to be replaced by Clinton.

Washington had early news that Clinton was going to move British forces out of Philadelphia back into New York. He informed Arnold, whose rank and seniority had been restored, that he was to be made Military Governor of Philadelphia. Arnold was delighted—the top post in the biggest, richest city of America.

On May 30, Arnold sought out Brigadier General Henry Knox, Washington's portly Artillery Commander, to renew his oath of Allegiance to the United States.

On June 9, 1778, Major General Benedict Arnold entered Philadelphia as its Military Governor, one day after Clinton's departure.

That critical day marked the second major event in Arnold's remaining career as an American Officer.

Arnold reveled in the singular position of power he now held in America's greatest city. Philadelphia, having been occupied by the British for more than a year, was no hotbed of revolt. More than three thousand Tories had left with Clinton, hundreds, probably thousands more of dubious persuasion remained. The city had, in fact, produced an enormous gala, complete with fireworks, banquets and a costume Ball in honor of Sir William Howe when he left for London.

Arnold promptly moved into the fanciest quarters he could find and entertained lavishly. Then he proceeded to irritate every merchant in town by slapping on such tight restrictions as to have the force of Martial Law. He hadn't been in town a month before Congress was threatening to bring charges against him for high-handed actions of one kind or another, including loose use of money.

The third major event in Arnold's career was meeting Peggy Shippen, and after that all the rest meant very little.

Peggy, a gorgeous 18-year-old daughter of Judge

Edward Shippen, was one of the crown jewels of Philadelphia society. She captivated Arnold from the very start.

Benedict Arnold, hero of Quebec and Saratoga, Military Governor of Philadelphia and an exciting figure in his own right was a formidable suitor and Peggy fought no serious defensive action. Her father was not wholly entranced, but less than a year later, Philadelphia turned out for the gala marriage of General Arnold to Miss Peggy Shippen.

During the courtship Arnold had run across the tracks of Major John Andre, a dashing young British officer who had been one of Peggy's favorites. He had painted her portrait, he sang her songs, he designed her costume for the extravaganza given General Howe.

There can be little doubt that Peggy was good for the ego of Arnold whose ego needed little nourishment. She sympathized deeply with his continued harrassment by the likes of Gates, and the popinjays in Congress, and the bleats of the Philadelphia merchants. He was far too noble a man to be nibbled to death by ducks.

Arnold agreed. He had not been appreciated, he had been harassed from the beginning. While he lay in a hospital in Albany, "they" held a court martial on charges that he strong-armed Montreal merchants! He was even now demanding another court-martial to clear his name of all this niggling about the cost of his entertainment and his treatment of Philadelphia merchants.

So it was not long before he put himself in touch with General Clinton. First through messages carried to New York by Joseph Stanbury, a Tory shopkeeper. Arnold flatly suggested that he change sides: "I am ready to offer my services to restore His Majesty's usurped authority . . . I am prepared to join his Army at once."

Major Andre, now Clinton's aide-de-camp, urged the General to co-operate. Andre, in fact, took over as Clinton's contact with Arnold.

The negotiations dribbled along for a year, mostly on matters of reward, indemnifications, rank, etc.

Meanwhile Arnold's plea for a courtmartial was heeded and he was tried by a court in Morristown, New Jersey and cleared of all but two minor counts. But a "Public Reprimand" was ordered and carried out. Arnold was livid.

In mid-1780, Arnold really brought the negotiations with Clinton to a specific and important climax. He flatly offered to surrender West Point to the British for 20,000 Pounds, the rough equivalent of about $125,000 at that time.

Later that month Arnold left Philadelphia and reported to Washington. He was set back on his heels when, to his amazement, Washington offered him Command of the Left Wing of the American Army.

Arnold had been campaigning hard for the Command at West Point and now had to maneuver. Pleading that he was not physically fit for a strenuous field campaign, he let the word drift back to Washington through Alexander Hamilton. It worked. Early in August, Washington named Arnold Commandant at West Point.

From there on things moved fast.

On September 22, Major Andre slipped ashore after midnight just below Haverstraw from the British ship "Vulture" for a secret conference with Arnold. As it happened, Col. James Livingston decided this was a good time to fire on the "Vulture." The skipper, fearing a continued bombardment, weighed anchor and slipped down river to Dobbs Ferry.

Andre was in a spot. He was in civilian clothes, Arnold had given him documents which were hidden in his boot and he had to make his way cross-country.

Andre had a safe-conduct pass from Arnold but he was stopped by three volunteer New York militiamen near Tarrytown. Andre at first thought they were Tories until they started to search him, probably more interested in loot than in documents. Andre tried to bribe them and was turned over to Lt. Colonel John Jameson at North Castle.

Operating under the name "John Anderson," Andre did carry a bonafide pass from Arnold. In fact Arnold had earlier alerted Col. Jameson to be on the lookout for a Mr. Anderson and to send him to his headquarters if he showed up.

Jameson then made the worst possible decision as far as Andre and Arnold were concerned. He decided to send Andre through to Arnold and send the mysterious papers directly to General Washington.

In order to inform Arnold, Jameson sent a note by Lieutenant Solomon Allen to Arnold saying:

"He has a passport signed in your name and a parcel of papers taken from his stocking which I think of a dangerous tendency." He described the papers and said he was sending them on to Washington.

It was less than an hour later that Major Talmadge, actually Washington's secret service operative in New York, returned to North Castle from a scouting expedition. He was told about Anderson and shown the papers. He immediately sent a rider to intercept Andre and return him to North Castle and then transferred him further inland to Salem.

The word was a long time reaching Arnold.

On Monday, September 25, he was breakfasting with Peggy at Robinson House, his official residence, just across the river from West Point. Three young officers arrived with the word that Washington himself would be arriving later in the day. While the introductions were going on the messenger arrived from North Castle and Major General Benedict Arnold knew disaster had struck.

There was nothing to do but get out—fast.

He managed to get Peggy aside briefly. She sensed from his actions that he was desperate.

"Andre's been caught. I must fly for my life. I haven't a moment to lose."

She heard the words and saw all her bright plans crashing in the morning sun.

"You'll be safe here," Arnold assured her rapidly. "You know nothing, nothing at all. They will not harm you."

In minutes he was at the landing, shoving off in the barge which stood at readiness to take him across the river to West Point each day.

But not today. Today he drew his pistol and ordered the astonished boatmen—"Downstream!"

That's how it was with Benedict Arnold for the rest of his long life.

In New York Clinton treated him cooly, was bitter about Andre's capture as a spy. Arnold was finally paid 6,000 pounds sterling, about $65,000. He was made a Brigadier General and the British used him in a bloody attack on New London, Connecticut, and later against Richmond, Virginia.

Arnold went to London in December 1781, followed almost immediately by Peggy and their two sons. Arnold was presented to George III and for a while had his ear with vigorous new plans to subdue America. Neither the Foreign Office nor Parliament would listen.

Arnold finally got a 32,000 acre land grant in Canada.

When he died on July 4, 1801, he left three sons by his first marriage, four sons and a daughter by Peggy Shippen and one illegitimate son, John Brant, mothered by a Canadian Indian.

Three years later, at the age of 44, Peggy Shippen died. Both are buried in Battersea Church, London.

Major Andre was sentenced to death by hanging at Tappan, New York. Throughout his ordeal he bore himself with honest courage and great dignity. He was hanged in full uniform on a crude gibbet after adjusting the noose himself, asking only one thing: "All I request of you now, gentlemen, is that you bear witness that I met my fate like a brave man."

Years later a plaque was erected to the memory of Major John Andre in Westminster Abbey, shrine of Britain's greatest heroes.

Arnold was seen to visit it once.

The only American monument to Major General Benedict Arnold is on the Saratoga battlefield. It does not bear Arnold's name but features a stone carving of the boot Arnold wore on his left leg—twice injured in the American cause.

The War Moves South

Great powers strangely bogged down in frustrating wars in lands they do not know, against foes who will not yield, almost always seek the elusive "Master Plan" which promises quick victory.

Burgoyne sold such a scheme to the British planners with his "Down from Canada—up from New York" strategy in 1777. It looked good for the first couple of rounds but was crushed at Saratoga.

As early as 1778, the British High Command turned to a new master plan for a knock-out victory. The new vision of victory was to invade the South, beginning with Georgia and expand northward. There was a continued British belief—founded on nothing—that southern Tories would pour out by the thousands in the King's cause.

The late James Street, one of the most delightfully uninhibited writers of American history, described the situation this way in his book "The Revolutionary War," (Dial Press, 1954):

"The Southern frontier had been buzzing, but there had been no important battles since the British had lost at Charleston in the early rounds. The Indians were lurking, looting and skirmishing out along the western boundary of North and South Carolina and partisan bands everlastingly were mixing it up with Tories. The Revolution already was a bush-league civil war in the South and then England foolishly changed the South into the main theater, changing a chicken fight into a barroom gouging.

"First they moved down and stormed Savannah (December 1778) and sealed off Georgia without much trouble. Then they began stomping out the little revolutionary fires, and this is when they began running into the Southern guerillas. These Partisans didn't fight by the rules as England knew them. They had no regimentals and drill masters. They had horses and rifles and pine torches. They raided and burned and pestered the British like a swarm of yellowjackets. These bushwackers kept the British so upset that the Continental command figured we might even retake Savannah.

"The French fleet moved in with thirty-five ships and four thousand troops. Down came General Benjamin Lincoln to command the Americans. He was one of the Massachusetts Lincolns, a fat fellow and no kin to Abraham. He had 1,400 American troops to work with France's 4,000. The British in Savannah had only 3,000 men under the leadership of General Prevost.

"The British beat everything that France and America brought up. Our side suffered eight hundred casualties, and one of the dead was Count Casimir Pulaski. (September 1779)

"England was riding high in the South for the time and the Tories came out of the bushes and pitched in to help the King's side. Many of these Tories had sworn fealty to the Continental cause, but now that our side was taking a beating they went back to their first love.

"General Clinton left enough soldiers in New York to keep Washington tied down and he himself personally led an army of 8,000 down to South Carolina to take Charleston. His forces swelled to 14,000 and he laid siege to the city. It was the job of General Lincoln to defend Charleston and he couldn't do it. The city fell after a grinding siege (from March 29 to May 12, 1780) and this was the heaviest American defeat of the war. The British lost only 255 men, but captured our entire garrison of 5,400 men. We looked bad at Charleston, mighty bad.

"Clinton went back to New York to handle things up there and left General Cornwallis in charge of Southern operations. He wasn't much but he had a good man working for him. That would be Banastre Tarleton, a heller if there ever was one. He was rough. A killing man. And he loved to fight. He asked no quarter and he gave none and told the Americans either to stand up and slug or run and get killed. He didn't have time to mess with prisoners. They called him "the Butcher" and "No-Quarter Tarleton.""

After the fall of Charleston there was, for all practical military purposes, no organized American resistance in South Carolina.

It was a hot summer of partisan fighting—truly a civil war with three superb partisan commanders keeping a flicker of resistance alive. They were Francis Marion "The Swamp Fox"; Thomas Sumter "The Carolina Gamecock" and Andrew Pickens, an Irishman who needed no *nom de guerre*.

They engaged in a series of bushwacking engagements in the hills and swamps just to keep the British aware of a fighting American presence.

Major General Baron de Kalb did have a small force of Continentals in North Carolina: Four Maryland regiments under Smallwood, three regiments under Brigadier Mordecai Gist. The Cavalry troops which had been so brilliantly led by Pulaski were now attached to deKalb's small army.

Congress, whose eye for combat Generals was, to say the least, flawed, now sent General Horatio Gates to take command in the South. Thus one more disaster was built into the system. It came sooner than expected, at Camden.

Hogan's Law set in—everything that could go wrong did go wrong. Gates wandered South with de Kalb's small force, got lost, failed to catch up with his supplies, fed the army green corn so they could add dysentery to their other miseries.

Eventually he simply ordered an overnight march on

Camden, South Carolina—the strongest of several posts the British had manned along the Northern border area of the State.

Cornwallis, well aware of Gates crashing through the countryside, moved to Camden with re-enforcements.

On the morning of August 16, 1780, the two armies faced one another. Gates had nearly 3,000 men, about 1,000 of them veteran Continental troops, the rest militia. Cornwallis had about 2,300 men of whom about 1,700 were veteran troops, including a cavalry unit of about 200.

Gates' line of battle put his veteran troops—all of them —on the right; North Carolina militia in the center and Virginia militia on the left.

The result was not long in coming. In the early morning the British attacked all along the line, supported by brisk artillery fire.

All but one of the American militia units collapsed quickly into headlong retreat, de Kalb and Gist with 600 Continentals on the right held firm, then even mounted a counter-attack and were making some progress—until de Kalb called for the reserves and found they had melted away. Still they hung on awhile until forced back.

At this point, when the issue was already clear, "No Quarter" Tarleton and his cavalry came charging in cutting and slashing. When de Kalb was captured he had eleven wounds and died three days later.

It was a bloody loss, one of the worst defeats of an American army in any field battle of the war.

American casualties were 1,050, British losses were 320.

Nobody caught up with Gates—he had high-tailed out of there fast. In actual fact he reached Hillsboro on horseback, nearly 200 miles away, in three days flat!

It was a low point—a very low point in the struggle for American Independence.

The American Flag

In the early stages of the Revolutionary movement in America several Colonial flags gained some visible prominence. Among them were:

The red Taunton flag with the Union Jack and the words "Liberty & Union."

The Gadsden Flag with its coiled snake and the warning "Don't Tread on Me."

The Pine Tree Flag with a green tree on a field of white and the legend "An Appeal to Heaven."

On June 14, 1777, the Continental Congress made a decision which must have seemed routine and of minor importance in the great sweep of events then unfolding.

On that day the Congress approved a design for the first official American flag.

Francis Hopkinson, a musician, a writer of verse and a sketch artist was a member of Congress from Delaware and a signer of the Declaration of Independence. It was his design that Congress approved— thirteen alternate red and white stripes with a circle of thirteen white stars in a rectangular field of blue in the upper left-hand quadrant.

Legend has it that Betsy Ross made the first actual flag from Hopkinson's design. Legend goes one unbelievable step further and has George Washington, Commander-in-Chief of the Continental Army, personally consulting with Betsy about the flag. It is safe to say that this cozy picture never occurred.

But Betsy Griscom was indeed a Philadelphia girl of uncommon energy who ran away from home to marry an upholsterer named John Ross. John and Betsy ran a shop on Arch Street in Philadelphia. John was killed while serving as a militiaman and Betsy took over.

So it is quite likely that Betsy was hired to sew the first flag. But it is just this side of hokum to believe that Washington, given his naturally cool reserve and given the enormous problems he was facing by mid-1777, would find his way back from his armies to Betsy's shop in Philadelphia for a look at the new flag.

As a matter of fact the first time anybody ever heard the Betsy Ross-Washington story was when William Canby delivered a paper to an historical society in 1870. Mr. Canby, it turns out, was a great-grandson of Betsy Ross.

As a matter of fact Betsy was quite a woman and needed no legend makers. She was one of seventeen children, lived to be eighty-four years old and had seven daughters of her own by three husbands.

Whether the Continental Congress realized it or not, the American Flag was to assume a role of unique importance throughout the history of this country. No other nation in the world reveres its national ensign as America does. In no other culture does a flag so stir the popular imagination, engender such spontaneous waves of emotion or play such an important role in public and private events at all levels of society.

The American Flag is not called "Old Glory" by accident. The United States of America was born without the traditions of a long history, without a revered and ancient culture. There was no tradition or aristocracy or noble families or the pomp and ceremony of historic pageantry and ancient victories by sainted heroes.

The American Flag must substitute for all of this and, in its own brisk presence, be the one common symbol of national pride in a nation whose people come from all over the world by their own free choice to be Americans.

BETSY ROSS AND THE FLAG
JUNE, 1777

The "All-seeing Eye" watches over what never happened—Betsy Ross and George Washington with the first flag. But the magical flag did happen, and prevailed and still does.

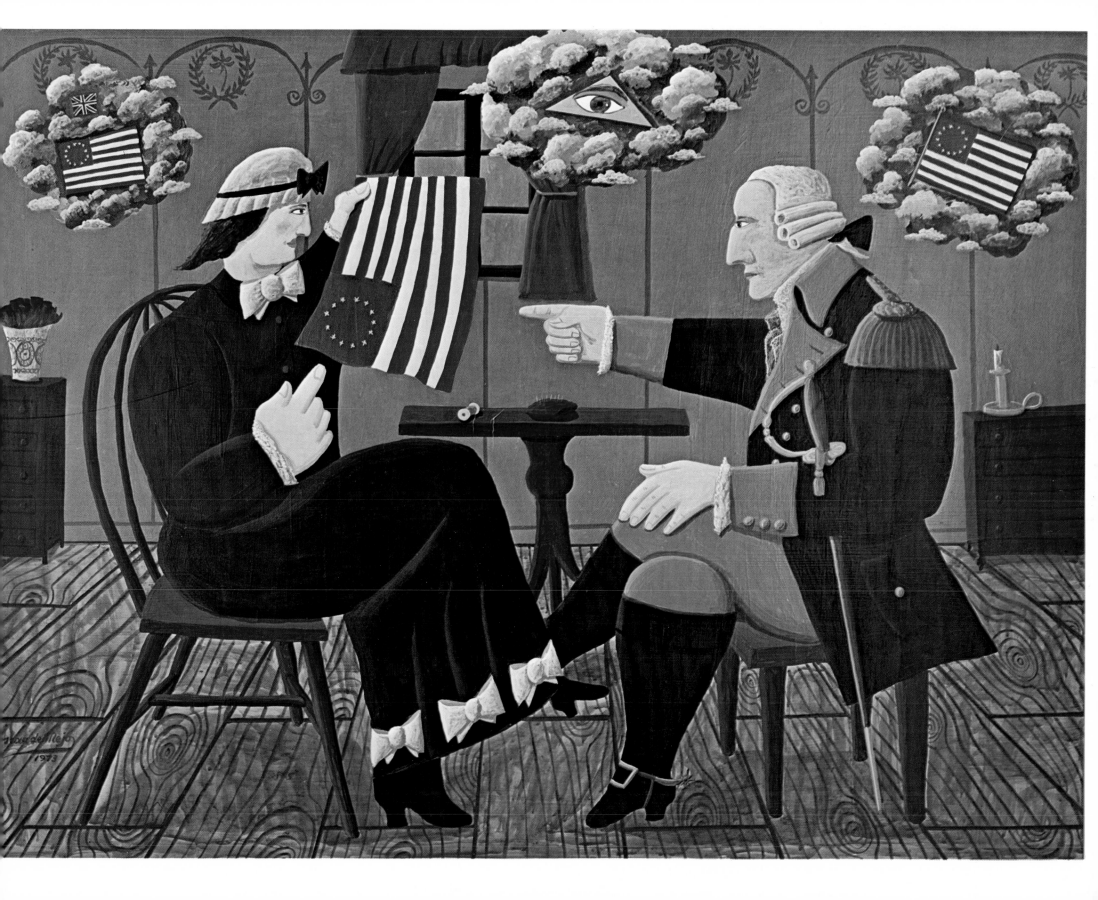

Victory At King's Mountain

In the Fall of 1780, Cornwallis began his move into North Carolina. Major Patrick Ferguson was detached from the main body of the army, operating independently in the mountains Northwest of Camden just below the North Carolina border. He had a force of about 1,000 Tories. Word of this presence had reached the "over mountain" men in the rugged Watauga settlement in what is now Tennessee.

Just before noon on October 7, Major Ferguson suddenly found himself confronted by nearly a thousand mountaineer riflemen from Virginia, Tennessee and the Carolinas. Ferguson retreated up King's Mountain to a position he believed to be impregnable and waited for an attack to come if it would.

It came! The American mountain boys were riflemen of extraordinary skill. They simply swarmed up the mountain and poured on an incredibly accurate fire.

When it was all over Ferguson—the only Britisher in the battle—was killed along with more than 300 of his troops. Virtually all of the rest were wounded or captured.

The whole thing was over in less than two hours, but news of the vigorous American victory broke a very long dry spell. It was a victory to hearten the South.

Not only that, it changed Cornwallis' mind. He decided to end his northward march and go into winter quarters at Winnsboro, South Carolina, about thirty miles west of Camden.

The First Team Takes Over

Congress had struck out in its selection of army Commanders for the war in the South.

Robert Howe, with a pitifully small force, lost at Savannah.

Benjamin "No Kin" Lincoln was weak at Charleston and absorbed a major loss.

The incredible Horatio Gates, Congress' favorite stuffed General, not only lost all the rest, but most of his army as well.

As always, when things had gone wrong and disaster seemed close at hand, Congress asked Washington to take over and name his own Commander for the South.

Washington promptly named Nathanael Greene, who should have been there in the first place. Greene was probably Washington's best all-around Army Commander—a perceptive, intelligent strategist; an enterprising and effective tactician and, above all, a trusted, reliable leader of men. There were, in fact, those who thought Greene superior to Washington as a field Commander. Fortunately Greene was not one of them.

Greene was prudent enough to ask Congress for arms, clothing, wagons and supplies. What he actually got were promises and $180,000 in Continental paper money worth far less than the same number of hen's eggs.

After urging Washington to keep up the pressure "unceasingly for supplies and clothing" Greene started on his way South. He was to be joined there by Steuben.

In late November, 1780, Greene had a strained but sympathetic meeting with Horatio Gates at Charlotte, North Carolina, where he took over command of the "grand army" in the South.

On paper the army consisted of about 2,500 men, including small units of artillery and cavalry—but only about 1,500 men were actually present and fit for duty.

It was, in all respects, a "sad sack" army, half clad, poorly fed and virtually without discipline. It had been living off the land and had stripped the countryside clean in its search for food and cover.

One thing was painfully apparent to Greene; even at full strength this army was simply not strong enough to do battle with Cornwallis. The risk of losing the only American army in the south was just too great.

Greene then made a decision which would horrify all "Text Book" Generals. He decided to split his force into two armies, a risky move as Washington had learned in New York and Cornwallis had just learned again when Ferguson's force was winged off and clobbered at Kings Mountain.

But Greene was not faced with a theory, he was looking for survival and victory. Two separate armies, one under his own command, the other under that stalwart Warrior Daniel Morgan, could live off the land easier as separate units. Cornwallis would have two moving targets to watch and worry about in rugged country. Greene also felt his men were more at home, more mobile and accustomed to more self-reliance than the far less flexible British regulars.

Greene gave Brigadier General Dan Morgan command of the light infantry—about 400 Maryland and Delaware Continentals, 200 Virginia riflemen and a light cavalry unit of something over 100 under Col. William Washington, a cousin of George.

The second army division numbered something under 1,500 Continentals. General Isaac Huger of South Carolina was the commander but Greene himself stayed with this division.

Nathanael Greene was a prudent planner. Winners usually are. He had with him General Thaddeus Kosciusko and Major Edward Stevens, both competent engineers and surveyors. He put them to work exploring and mapping the country on both sides of the North and South Carolina border, with special emphasis on the main rivers. They were also to round up or build boats which could be easily portaged from river to river.

By mid-December they were ready to move. Greene ordered Morgan to join up with General William Davidson and his militia unit and move into an area between the Broad and the Pacelot Rivers just south of the North Carolina border.

Morgan was to operate "defensively or offensively" as

he occasion arose, but to avoid surprise at all cost.

Greene himself moved to Cheraw Hill on the Peedee River, a site selected earlier by Kosciusko. He was nearly 140 miles east of Morgan. Greene had about 1,100 men, combined Continental and militia units.

It was a long, tough march for both Morgan and Greene. The Winter rains had set in, men were hockhigh in mud, wagons bogged down, food was short. By the end of the year Morgan was encamped on the Pacelot and Greene, with the second army, was relatively snug at Cheraw Hills.

Early in 1781, reenforcements began to arrive for Greene at Cheraw. First was "Light Horse" Harry Lee's Legion, 110 horsemen and about 200 foot soldiers. They were a well disciplined unit, dashing in their green uniform coats. Col. John Green also arrived with 400 Virginia militia.

Cornwallis, still at Winnsboro, S.C., was also reenforced by 1,500 men sent down by Clinton. Cornwallis now had about 4,000 men—more than both of Greene's armies. More important Cornwallis had veteran, disciplined battle-tried veterans including nearly 1,000 Hessians. It was a tough, tight little army.

Banastre Tarleton thought Greene was slightly daft to have split his force in two. Cornwallis was quicker to understand Greene's reasoning: If the British moved against Cheraw Hills, Morgan might strike at such tempting targets as Ninety-six or Augusta. If Cornwallis moved against Morgan, the way to Charleston would be clear for Greene.

Faced with these realities Cornwallis split his own army into three attack forces. One unit under Major Leslie was sent to hold Camden. Cornwallis himself was to take a force into North Carolina and Tarleton was to seek out Morgan and smash him.

The Battle Of Cowpens

Banastre Tarleton took out after Morgan's Americans with a force of about 1,100 almost all seasoned British veterans. It included Tarleton's own Legion numbering about 550 cavalry and foot soldiers; about 500 men in regular regiments of Highlanders and Fusiliers; about 50 more light cavalry and a small artillery unit with light field pieces.

Tarleton's chief weakness was his own fierce impatience. He drove his force hard in tight pursuit of Morgan. There was no doubt about it, "No Quarter" Tarleton was spoiling for a fight.

M organ chose the spot, an open woodland which backed up against a curve of the Broad River about two miles South of the North Carolina border.

The wide plain, which had been regularly used by a prosperous Tory as pasture for his cattle, was like an open stage. There was no swamp or thicket for cover but a stand of chestnut and oak trees. Morgan's army, about the same size as Tarleton's, spent the night of January 6, 1781, on the battle site. Daniel Morgan, the "Old Wagoner," moved among his men, ate with them and told them how they were going to tan Tarleton's hide in the morning.

What faced Tarleton was this:

The battle site was crossed by two modest rises of ground. On the first of these Morgan had installed his best Continental Regulars. Beatty's Georgians, 150 men, held the right. Triplett's and Tate's Virginians held the center. The Maryland battalion of 300 held the left.

Lieutenant Col. John Eager Howard commanded this line with Daniel Morgan at his side.

Col. Andrew Pickens held a line of 270 raw militia in open ranks about 150 yards in front of Howard's line.

Major Cunningham of Georgia and Major McDowell of South Carolina were another 100 yards forward with a force of 150 picked sharpshooters under orders to take the cover of trees, fire only at short range and fall back firing.

Pickens' militia were under specific orders to hold their fire until the enemy was within 50 yards, then fire two volleys, retire to the left and circle behind Howard's Regulars to join Beatty's Georgians.

Col. William Washington and Lt. Col. Charles Mc-Call with their cavalry units were out of sight behind the second rise of ground.

It was an unorthodox, bold plan with the stamp of Dan Morgan all over it.

There is no doubt about it, Morgan knew his man and Tarleton co-operated fully, exactly as the "Old Wagoner" predicted he would.

At seven o'clock on the morning of January 7, 1781, Tarleton, aching for the fight though his troops were well worn from marching, sent three regiments of infantry, with light cavalry on each flank, into the head-on attack.

The first line of American sharpshooters did exactly as ordered—fired accurately from cover and slowly withdrew to their left to re-form in the rear. As expected they drew some pursuit.

Tarleton's main body advanced on Picken's militia who followed orders to the letter—at close range, well under 50 yards, they fired two volleys then wheeled and retreated to their left, circling behind Howard's regulars to re-join the battle.

As Tarleton's regulars pursued the "retreating" militia, Washington and McCall's cavalry swung around the same flank and tore into the British.

Meanwhile at "Center Stage" Col. Howard's Continentals held like a rock wall and poured very heavy fire into the British Regulars at extremely close range.

W ith Cavalry on their right, the militia units now pouring a cross fire in from the left and Morgan's center as solid as a rock, Tarleton was whipped and he knew it.

The entire British force fell back in retreat. Tarleton, with 40 cavalry-men made his escape from the field, hotly pursued by Col. William Washington, no mean

horseman himself. There was a brief and confusing flurry of mounted men, horses and flashing swords. Tarleton took a sword cut on the face from Washington, who himself was nicked in the knee.

The proud and dandified Tarleton had spent very few mornings in such misery as on this day of defeat at Cowpens.

For Daniel Morgan, only recently made a Brigadier General after more than five years of vigorous service, it was a masterpiece. Cowpens was probably the best executed open battle-field action of the war. And it was to be Morgan's last fight. Within a few weeks poor health, "fevers and the ague," forced his retirement.

British losses were shockingly high. 100 killed including 39 officers and more than 800 taken prisoner, 229 of them wounded.

Only 13 Americans were killed and 60 wounded.

There were other tangible rewards of the morning's work: 800 muskets, 35 baggage wagons, 100 cavalry horses and considerable ammunition. All most welcome.

For the sagging American fortunes in the South, for the disasters of Lincoln and Gates, Cowpens was a healing antidote—especially sweet because the loser was the proud and dangerous Tarleton.

Congress came through with a resolution of thanks and a gold medal for Morgan. Virginia, somewhat more practical, gave him a horse. William Washington and John Howard got silver medals and swords. Everybody got a great lift.

Greene's strategy was looking very good.

After Cowpens Cornwallis tried to pursue and isolate Morgan's army but Greene and the tough, tired Morgan eluded him and the two American forces joined on a retreat across the Dan River into Virginia.

Cornwallis, short of boats and supplies, decided not to pursue and withdrew into North Carolina.

After being reenforced in Virginia, Greene had an army of nearly 4,400 men and decided to go on the attack. On March 15, 1781, Greene and Cornwallis met at Guilfort Court House in North Carolina, about 25 miles south of the Virginia border.

Greene had set up a line of battle patterned after Cowpens, with one dangerous difference: The three American lines were separated far more widely, leaving the first line of militia feeling totally exposed.

Cornwallis, as Tarleton had done before him, mounted a frontal attack all along the line. It was toe-to-toe slugging, as fierce a battle as either Commander had ever fought. The Americans, though the larger force were far less experienced.

Greene's front-line militia units faded fairly fast but the Maryland and Virginia Continentals and Colonel Washington's cavalry counter-attacked in fierce hand-to-hand combat. So critical was the situation that Cornwallis resorted to a desperate measure—firing volleys of grape-shot at close range to stop the American attackers at the cost of mowing down his own retreating forces.

The battle ended in an American withdrawal after severely battering Cornwallis' army—at least twenty-five percent of his army was killed or wounded. He claimed a victory but absorbed a critical loss.

Cornwallis was too weak to continue his campaign in the Carolinas and, after a pause at Wilmington, moved into Virginia where he received re-enforcements including Benedict Arnold who in January had sacked and burned Richmond.

In total Cornwallis had a force numbering about 7,000.

The American force in Virginia under Von Steuben was hopelessly out-numbered. Lafayette with three

BATTLE OF COWPENS
JANUARY, 1781

In a swirling mass of men and horses, arrogant Banastre Tarleton, in his fur hat, is deflated by clean-cut, hatless William Washington—a great blow for virtue and freedom in the South.

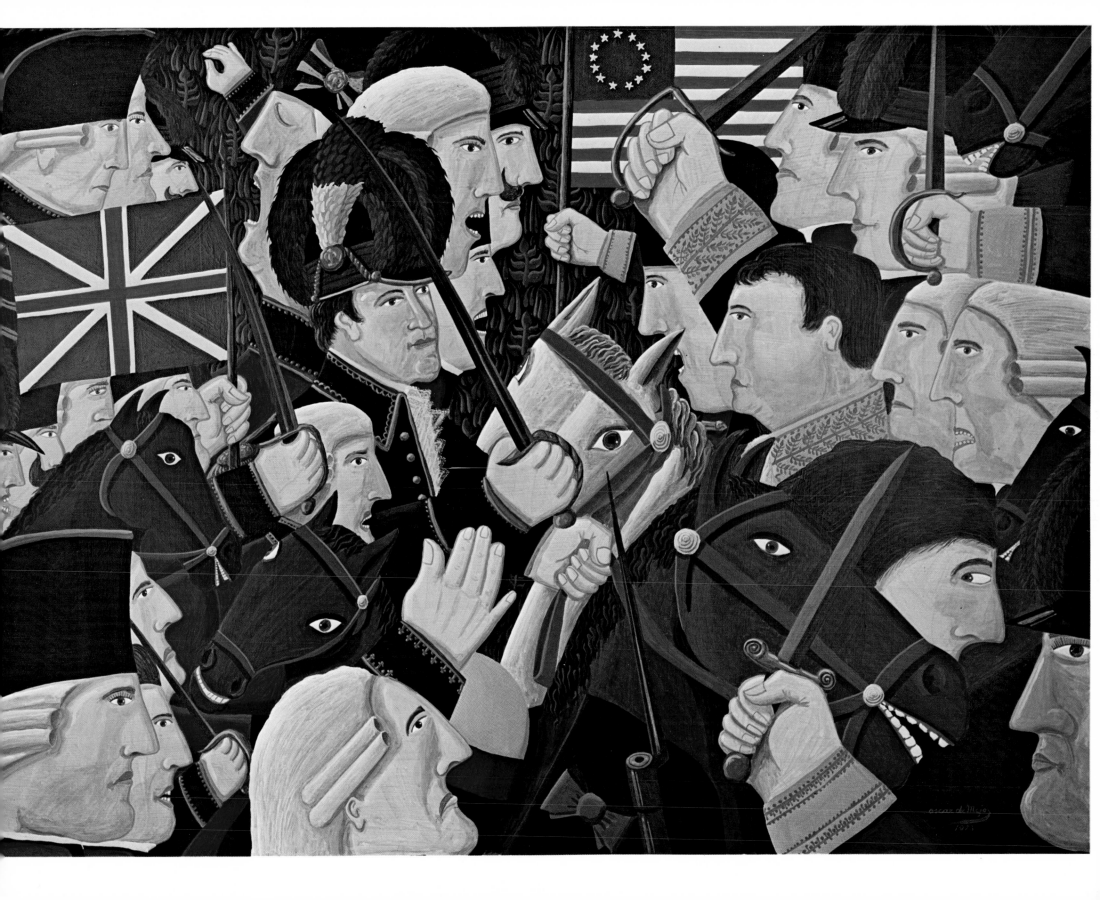

regiments was sent down by Washington and Wayne arrived shortly after with two more regiments.

On May 18, Greene assigned Lafayette to the Command in Virginia, and sent Wayne to join him. Through the Summer of 1781, Lafayette and Wayne led Cornwallis in a hit-and-run pursuit toward the Virginia coast.

By the end of June the American army had increased to nearly 6,000 men, nearly 2,000 regulars. The British abandoned Richmond on June 20 and on the 25th, Lafayette pressed them so closely at Williamsburg that the British army moved out to protect its rear.

By August 22, 1781, the entire British Army under Cornwallis was at Yorktown, with a small force at Gloucester, directly across the York River.

Lafayette promptly sent Wayne to cut off the retreat southward and then wrote Washington, strongly urging him to come to Virginia to take personal command.

"The British Army must be forced to surrender."

Lafayette wrote: "I heartily thank you for having ordered me to remain in Virginia. It is to your goodness that I am indebted for the most beautiful prospect I may ever behold."

The Move To Yorktown

While Greene and Lafayette were busy with a war of movement in the South the American cause in the North had been bogged down in military inactivity, severe financial problems and growing public apathy.

Washington's army around West Point numbered scarcely more than 3,500 Continentals, mostly New Englanders. There was a scattering of New York regiments on the Western boundary of the state. The balance were with Greene in the Carolinas or with Lafayette and Wayne in Virginia.

A French army of about 4,000 men under Rochambeau was inactive in Newport, Rhode Island.

Word reached Washington in May of 1781 that Admiral de Grasse was being sent with a strong fleet from France to the West Indies and thence to America to join Rochambeau. Washington's first thought was a combined action against Clinton in New York.

Washington, as he had before Trenton, sensed deep inside himself that a major offensive action was necessary—and soon.

Early in July, Rochambeau and his army joined Washington at Peekskill. They had been recently re-enforced by 700 men and brought word that more would be coming in July or August.

Washington was still intent upon New York. In late July, carefully screened by advance troops, Washington, Rochambeau and two other French Generals made a careful survey of the British positions and apparently decided against an attack.

News from Lafayette and Greene turned Washington's attention to the South and the possibility of snaring Cornwallis and his army in Virginia.

On August 14, Rochambeau received a crisp, clear plan from Admiral de Grasse who said he was leaving Santo Domingo on August 13, sailing for the Chesapeake with a force of 3,000 men. He would remain there until October 15.

Washington wasted no more time. He wrote Lafayette immediately, urging him to use his forces and Wayne's to keep Cornwallis bottled up until he and Rochambeau could join them.

The problem now was to keep Clinton unaware that the main American and French armies were heading South, leaving only Brigadier Gen. William Heath with fewer than 3,000 men to control the Hudson.

Clinton was sitting in New York with a well-fed, well-equipped army of 17,000 British and Hessian regulars.

As part of the feint, Washington's allied army marched down through New Jersey where they paused to estab-

lish what appeared to be a permanent encampment threatening Staten Island. The secrecy was tight. None of the troops knew where they were going and only a handful of senior Officers had any real knowledge.

Clinton never moved a muscle. It was well into September before his intelligence sources made it clear that Washington was headed South. By that time the allied army had passed through Philadelphia and concealment was no longer critical.

The armies covered more than 200 miles in 15 days and were at Head of Elk on September 6. Within two weeks they had all been transported to the James River and were ashore at Williamsburg by September 26.

Only once on the long hard journey South did Washington have any serious misgiving. Reports reached he and Rochambeau in mid-September that a British fleet under Admiral Thomas Graves had been hustled to the Chesapeake to give battle to de Grasse. For several days Washington and Rochambeau had to sweat it out, knowing full well that if the naval blockade was removed the cork was out of the bottle and Cornwallis could make his escape. On September 16, they got the word. de Grasse and his fleet were back in the Chesapeake. They had gone out to battle with the British and Graves had been no match for the fire-power of the French. His lighter British ships had been mauled and high-tailed it back to New York.

In retrospect this small naval engagement, laconically reported by de Grasse, was critical to the cause of American independence, yet not a single American was in the fight. In fact, few Americans had ever even heard about it.

But that was all behind him now as Washington established his Headquarters in the tranquil home of George Wythe on Palace Green Street in Williamsburg.

For Washington it was a return to his roots. Here was

the House of Burgesses in which he had served and where the sparks of freedom flew. Here was Bruton Parish Church where he had so often worshipped.

And he was in the house of his old and respected friend, George Wythe, a remarkable man of many interests—a serious student of astronomy, an experimenter in horticulture, a lover of music. Wythe was the man who taught Thomas Jefferson the Law and became the first Professor of Law at William and Mary College. He had served in The Continental Congress and was a Signer of the Declaration of Independence.

Washington was in his element and it felt good.

On September 18, Washington, Col. Henry Knox, his commander of artillery, and other staff officers paid their first visit to Admiral de Grasse on his flagship "Ville de Paris," the largest, finest warship in the world mounting 120 guns.

Thirty-one other French ships were close at hand to seal off Cornwallis from escape to the sea.

Admiral de Grasse proved a warm and understanding ally, readily agreeing to stay where he was until the end of October and to supply sailors and Marines for the land operation.

It was also agreed that Tarleton's force at Gloucester Point could not be contained with the present flimsy American presence, a single body of militia under General Joe Weedon. Rochambeau would send a combined force of French Lancers and Hussars plus Marines from de Grasse's fleet. The total force would be under the command of the Marquis de Choisy, a seasoned campaigner.

The last escape hatch was slammed shut on Cornwallis.

Siege And Surrender

Just after daybreak on September 28, Washington led his allied armies on the twelve mile march from Williamsburg to Yorktown.

It was an imposing military force of nearly 17,000 men, about 9,000 Americans and just under 8,000 French. By evening they occupied a line less than a mile away from the British outer-works at Yorktown. The allied line extended in a sweeping curve from the York River on the West, above the city, to Womsley Creek on the East.

French forces under Lieut. General Rochambeau held the left side of the line. The right side was manned by three Divisions commanded by Lafayette, Benjamin Lincoln and von Steuben. The Americans were under the Command of General Lincoln but Washington, as Commander-in-Chief, issued daily orders to the American forces.

Included in each of the armies, in addition to infantry, was its own complement of engineers, cavalry and artillery. General Henry Knox was in command of American artillery units.

It was painfully apparent that Cornwallis had never planned on defending Yorktown against a land-based siege. He had chosen the site for just the opposite reason—to be on a good harbor and seaport for easy access to the British Navy.

In the critical Fall of 1781, the nearest British Navy was in New York and Cornwallis and his army of about 7,400 were facing a bleak prospect.

The art of the siege is essentially the art of the squeeze —to surround the defended strong-point with entrenched troops and then move the attack closer and closer in a diminishing circle, while keeping the defenders under constant, pounding artillery fire as heavy and as intense as possible.

Basically it's an Engineer's business, with a minimum of heroics and a maximum of sheer weight and tenacity.

In looking back at these classic battles of 18th century warfare it is often necessary to remind ourselves that all battles in that era were "surface battles"—that is, they were fought only on the surface of the land or the sea. Visibility was, therefore, "line of sight" visibility aided, if at all, by the simplest of hand-held tele-

scopes, not the handiest tool in the world for a man on a galloping horse or dug into a trench.

Weapons, too, were essentially limited in range and accuracy to targets clearly visible to the naked eye.

All of these factors were of heightened importance in a "set piece" of the kind about to unfold at Yorktown.

The morning of September 30, brought the allies a very pleasant surprise. Sometime during the night Cornwallis had evacuated all of his outer-works except a Fusiliers Redoubt on the northwest opposite the French, and Redoubts 9 and 10 on the East side of town facing the Americans. The "gift" was hastily seized and allied forces quickly moved into the positions abandoned by the British.

The first week of October was devoted to basic preparations for the siege. Heavy artillery pieces which had been landed at the James River were hauled forward. Surveying and engineering work was pushed as fast as possible.

On the night of October 6, while the French staged a diversionary attack, nearly 4,000 men moved out in the darkness to begin the construction of the first parallel—a fortified line about 2,000 yards long, parallel to the British inner defense line. Its average distance from the main British position was less than 800 yards.

The squeeze was on. With 1,500 men working and nearly twice that number guarding them, the trenches could be dug to a sufficient depth between dusk and dawn.

By October 9, the allied artillery was ready. A French battery on the far left fired first and drove the British frigate "Guadelupe" across the river to the Gloucester side. Two hours later the American bombardment started, with Washington himself firing the first round.

The next day 52 siege guns were in action and the combined French and American fire virtually silenced the British guns.

On the night of October 11, work began on a second parallel even closer to the British position. After two nights of work it became apparent that the two British Redoubts on the right, Number 9 and 10, would have to be occupied in order to finish the new line.

What was to be the last infantry attack of the war was launched against the Redoubts on the night of October 14. In a spirit of competition the French assaulted Number 9, the stronger of the two points, and the Americans moved against Number 10. Within half an hour both were taken, chiefly by slashing bayonet attack. The next day Cornwallis wrote sadly to Clinton:

"The enemy carried two advanced redoubts by storm. My situation now becomes very critical; we dare not show a gun to their old batteries and I expect their new ones will open tomorrow morning . . . The safety of this place is so precarious I cannot recommend that the fleet and army should run the great risk endeavoring to save us."

He was right about the new batteries. They pounded away for two days straight.

Twice Cornwallis made desperate attempts to break out. The first came one day after the redoubts were lost. Just before daybreak on October 16, a force of 350 men desperately assaulted the American line at its extreme left. At terrible cost they succeeded in spiking a few guns but the thrust was repulsed and soon the siege guns were firing again.

Before midnight on the same day Cornwallis tried one more forlorn hope. He embarked a number of his men in small boats on the slim chance that they could cross the York River and somehow evade the allied forces at Gloucester. The boats did manage to land on the opposite shore but a violent storm broke and prevented any further such suicidal efforts.

Through all the days the allied artillery had been keeping up a murderous fire, the hours were filled with their thunder and the clear days of Autumn thick with cannon smoke.

Dr. James Thatcher, an Army surgeon since 1775, described it this way: "A hundred guns are at work. The whole peninsula trembles under the incessant thunderings of our infernal machines."

At ten o'clock in the morning on October 17—four years to the day after Burgoyne's surrender at Saratoga—French troops at the far left of the line began shouting and pointing through the smoky haze toward the British lines.

A patch of scarlet was visible against the sky, but it was not the vanguard of another desperate British thrust. It was, indeed, one small and lonely drummer standing stiffly on the parapet desperately beating a tatoo. The sound of gunfire began to taper off as he kept drumming his message. Soon he was joined by an officer waving a square of white cloth. A sudden silence fell over the French and American lines. An American officer ran forward to meet the British officer, blindfolded him and led him into the American lines.

George Washington was busy in the study at George Wythe's house catching up with correspondence and reports when an aide, bursting with excitement, broke in on him with a sealed letter rushed from the battlefield.

The tall Virginian broke the seal and the written words exploded into his consciousness:

"I propose a cessation of hostilities for twenty-four hours, and that two officers may be appointed by each side to meet at Mr. Moore's house to settle terms for the surrender of the posts of York and Gloucester. I have the honor to be, Sir, your most obedient and humble servant, Cornwallis."

What an impact those words must have had after the years of struggle, of retreat, of keeping the cause alive in dark hours when it was flickering and weak!

But Washington re-acted quickly, called in John Trumbull of Connecticut and John Laurens of South Carolina and carefully worked out his answer.

BRITISH SURRENDER AT YORKTOWN OCTOBER, 1783

A gala and brilliant day! The ladies in big hats watch the show from boats in the river. American and French heros form lines of victory through which the British march to defeat and surrender.

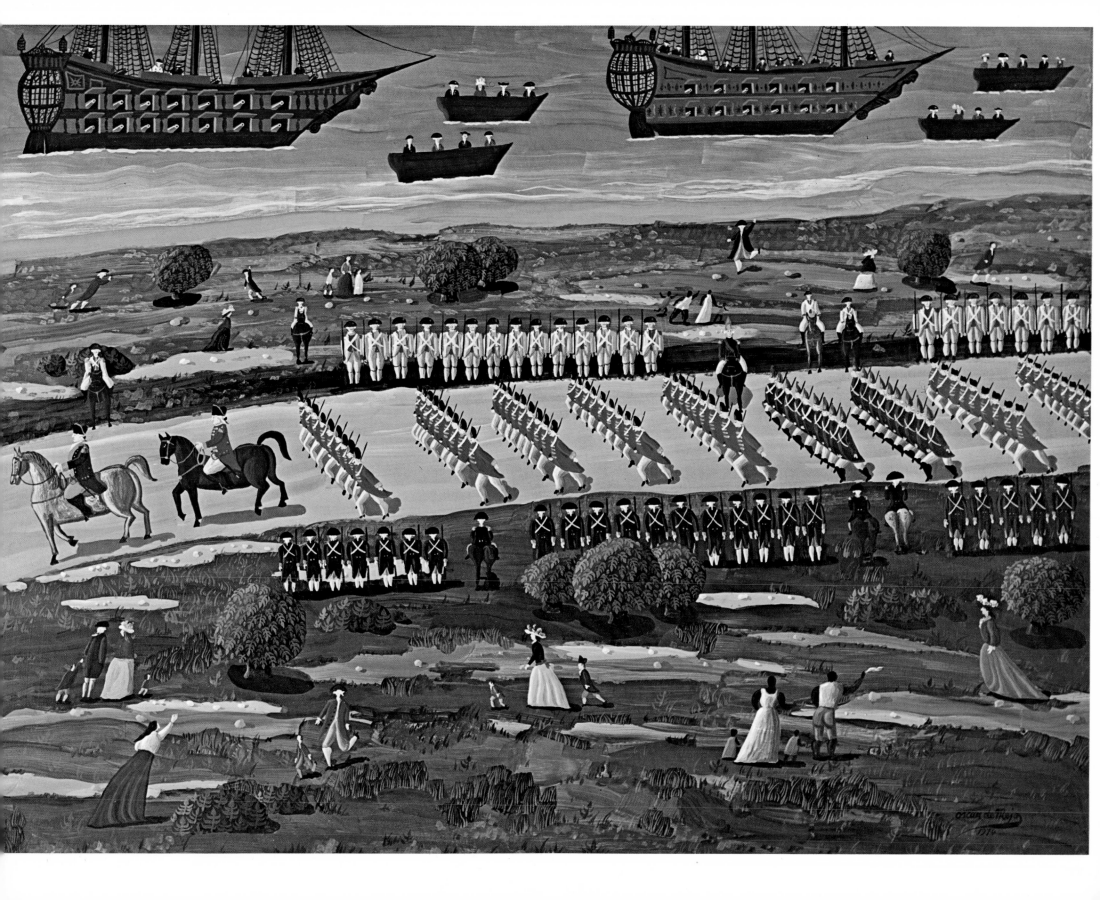

"An ardent desire to spare the further effusion of blood, will readily incline me to listen to such terms as are desirable."

Now Washington was very definitely in command. He allowed Cornwallis just two hours to submit his proposals—and they were delivered. Cornwallis proposed that his troops be returned to England on parole, not to serve against France or America during the war or until exchanged.

Washington's answer was quick and terse:

"You will get the same terms granted the American garrison at Charleston."

Cornwallis had no choice, the terms demanded complete surrender of all elements of his force, British and German, as prisoners of war. Details of the surrender were to be worked out immediately by four commissioners.

It was almost midnight when the Commissioners had hammered out a draft of proposed surrender terms. Washington went over the proposals in detail, revising some, rejecting others.

Early the next morning Washington ordered that the Articles of Surrender be copied in final form. Cornwallis was ordered to sign them by 11:00 a.m. and the entire British garrison was to march out and lay down its arms at 2:00 p.m.

Washington, Rochambeau and Admiral Barras representing the ailing de Grasse, met on the battlefield just before 11 o'clock. An orderly delivered the papers signed by Cornwallis and his Navy Commander Capt. Symonds.

At the bottom of the agreement Washington wrote:

"Done in the trenches before Yorktown in Virginia, October 19, 1781." He signed it simply "G. Washington."

Shortly after two o'clock the British and Hessians marched into view to the cadence of drums and the

WASHINGTON'S FAREWELL
DECEMBER, 1783

"The Spirit of Liberty" has grown so big she overpowers the mere men in Sam Fraunces' upstairs room. Tiny on the wall is the infant nation, bearing its flag as brave men weep!

sound of music. Cornwallis was not there, he pled illness. The troops, brilliantly dressed, were led by Brigadier Gen. Charles O'Hara, second in command.

O'Hara, bearing the symbolic sword of surrender had a hard time getting rid of it. First he offered it to Rochambeau, as one European professional to another. Rochambeau, without a word waved him toward Washington.

Once again O'Hara offered the sword, but protocol set in. O'Hara was not considered eligible to deal directly with the Commander-in-Chief. Washington designated Major General Benjamin Lincoln, his Deputy Commander. It was simple justice that the American General who had surrendered at Charleston should receive the enemy's surrender at Yorktown.

O'Hara was finally rid of the sword.

General Lincoln told O'Hara the British and Hessian troops were to lay down their arms in a nearby field where a circle of French Hussars sat astride their horses. The defeated troops were to reach the field by marching between ranks of allied soldiers, French on the right and American on the left. The prisoners of war were to stack their arms and march back out.

While they were turned out well, the British and Hessian troops seemed a bit ragged and disorderly, some downright sullen. To put it simply, as many an American soldier did, "the beaten British prisoners appeared to be much in liquor."

Legend has it that the British march to surrender was made while the Regimental Band played "The World Turned Upside Down." This durable tale has been challenged in recent years by scholars of music. Richard S. Hill, head of the reference section, Music Division, of the Library of Congress, was quoted on the subject by North Callahan in his book "George Washington, Soldier and Man."

Hill says this: "Anyone with the slightest familiarity with military music in the 18th century would be immediately suspicious of that tale."

Probably so. But the fact is the world was "Turned Upside Down"—music or no music.

When the day ended 7,247 British and Hessian troops plus 804 seamen had surrendered and were prisoners of war. Captured equipment included nearly 250 pieces of artillery, thousands of small arms and a vast quantity of equipment and supplies.

Considering the intensity of the siege, casualties on both sides were relatively light. The Americans lost 20 killed and 56 wounded. French losses were 52 killed and 134 wounded. Cornwallis lost 156 killed and 326 wounded.

Washington selected Lieutenant Colonel Tench Tilghman of Maryland, one of his most trusted aides, to carry the message of victory to Congress in Philadelphia.

Traveling hard in spite of weakness from fever, Tilghman reached Philadelphia at two o'clock in the morning on October 22, and delivered the great tidings into the hands of Thomas McKean, President of Congress.

A watchman who had led Tilghman to McKean quickly spread the word. Before dawn the city was ablaze with festive candles and a mood of wild rejoicing.

The news did not reach London until November 25. Lord North received it with dismay "as he would take a musket ball in the chest." George II was shocked but stubborn. He was still of a mind to press on with the war.

There is no evidence whatever that Washington or anyone in his army, or in the Congress, believed that the great victory at Yorktown would end the long War for Independence.

Washington, indeed, regarded 1782 as a critical year and was most anxious to press ahead. He made every effort to persuade Admiral de Grasse to join him in a combined assault on the British at Charleston, or at New York.

But de Grasse refused on the grounds that he had already overstayed his time. On November 5, he sailed for the West Indies.

Washington split his army, leaving a small force to re-enforce Greene and marched the main body north to defend West Point and the Hudson.

In May 1782, Sir Guy Tarleton replaced Clinton as British commander in New York. Washington could hardly regard this move as a sign of British defeat. Carleton was probably the best General Britain had in America during the entire war. Washington could be thankful that London had kept him buried so long in Canada.

But there was one thing Washington could not know: Lord North's government had fallen, new Ministers were quietly taking over and Carleton was under secret orders to withdraw all British garrisons in America.

The first unmistakable sign that a victorious peace was in the making came late in 1782, when Carleton ordered the evacuation of Savannah and Charleston "in consequence of an unsuccessful war."

Through the Summer and Fall of 1782, peace negotiators labored in Paris. It is unlikely that the United States, in its two-hundred year history, has ever been represented better than it was in this first diplomatic encounter with European diplomacy.

John Adams, Benjamin Franklin and John Jay were there to see that American Independence was clearly established and solidly backed—no secret clauses, no private deals. And there was plenty of jockeying.

Adams was a formidable intellectual force. Franklin, of course, had already had several successful rounds in Europe and was a shrewd political wrangler. But it was John Jay, suspicious of all Royal ministers and bag-carriers, who never let anybody forget that one thing, and one thing only, was important to him: American Independence, absolute, unclouded and total.

On November 30, 1782, agreement was reached.

The formal Treaty of Peace was signed on September 3, 1783, after England came to terms with France and Spain.

It had been a long eight years since Lexington.

The War for Independence was over.

Now the long American Revolution could really begin.

The Hiatus After Yorktown

The long "gray period" between victory at Yorktown and the signing of a Treaty of Peace—from October 1781 to April, 1783—was a delicate and touchy time for the emerging nation and its leaders.

Nothing seethes and boils more ardently than an idle army, particularly when it has been on chronically short rations and no pay.

Washington left Williamsburg in November, 1781, stopped off briefly at Mount Vernon and went on to Philadelphia where he spent most of the Winter. In late March, 1782, he was back with his main army at West Point—leaving the mopping up operations in the Carolinas and Georgia to Greene and Wayne.

Officers and men were complaining bitterly to anybody who would listen and were bombarding Congress with complaints. They were not without reasons. Basically they feared that Congress would simply ignore its promises and discharge them empty handed after their years of hard service.

There were other dark stirrings and concerns. Washington received a letter from Col. Lewis Nicola suggesting that "this new nation become a monarchy with Washington its King . . ." Washington blasted Nicola in no uncertain terms: "I view it with abhorrence and reprehend it with severity."

Henry Knox could feel the pressure growing. He wrote Washington: "The army has secretly determined not to lay down its arms until provision is made on the subject of pay . . . The expectation of the army,

from the drummer to the highest officer, is so keen for some pay that I shudder at the idea of their not getting it."

Rumors were rampant. Petitions of action signed "Brutus" were circulating among the troops.

Washington decided it was time to head off the growing restlessness. He called a meeting of his officers.

First he reminded them of his own long service. Then he denounced the recent mumblings of mutiny, the anonymous papers circulating among the troops. He strongly abhorred such sentiments and promised his own help "in attaining complete justice for all your toils and dangers. You may freely command my services to the utmost of my abilities."

"Let me entreat you," he said earnestly, "not to take any measures which, viewed in the calm light of reason will lessen the dignity and sully the glory you have maintained . . ."

When he finished, the meeting passed a resolution stating the confidence of the officers in the justice of Congress and repudiating the anonymous proposals for action which had been circulated.

It was a good, tough performance by the old War Horse.

Confidence and optimism were given a very important boost when Captain Joshua Barney arrived from France—on a ship happily named "Washington"—finally bringing to Congress an official text of the Treaty of Peace between the United States and Great Britain.

Upstairs At Fraunces Tavern

In 1765, when the idea of American independence was hardly more than the private dream of "The Sons of Liberty" and other ardent patriots, "Black Sam" Fraunces, who had come to New York from the West Indies, opened Fraunces Tavern in the old Delancey house on the corner of Broad and Pearl streets. It has flourished there for more than two centuries.

The greatest single day in all those years was the brisk, bright day of December 4, 1783. On that day the British were gone, they had sailed out of New York harbor the day before. This was the day the Officers who had served with General George Washington were to bid him farewell in the comfortable upper room at Sam Fraunces Tavern.

Fraunces had set a handsome buffet table—hot and cold joints of beef and veal, hams and sea foods and sparkling decanters of wine.

Fraunces knew most of the Officers and they knew him, for "Black Sam" had not been idle during the years his rooms had been filled with British officers. Nobody knew that better than Major Ben Talmadge who had been Washington's Chief of Intelligence through most of the war.

Talmadge was one of the first to arrive. Soon the room was filled by Generals Henry Knox, Alexander MacDougall, James Clinton, Baron von Steuben, Major Robert Burnett and many, many more.

The place was alive with the color of uniforms, the jingle of spurs and good talk.

But there was an air of expectancy over it all.

Shortly after noon the Commander-in-Chief entered and suddenly the room was filled with a silent emotion so strong it could almost be felt. Washington, too, was overcome by it and could utter only a few barely audible words of welcome.

Slowly the tall Virginian, visibly struggling to control himself, moved toward the table and with trembling hand poured a glass of wine. Other glasses were nervously filled, but the spell was not broken until, with painful slowness, Washington began to speak in tight and halting words:

"With a heart full of love and gratitude, I now take my leave of you. I most devoutly wish that your later days may be as prosperous and happy as your former ones have been glorious and honorable."

He raised his glass. By now there was no hiding the honest tears—and Washington was not alone. He forced himself to continue:

"I cannot come to each of you but shall feel obliged if each of you will come and take me by the hand."

Knox, huge, tough old Knox was the first to reach him, his cheeks wet with tears and his hand extended. Briefly Washington reached for the hand but then impulsively threw his arms around Knox in a strong embrace. One by one they all followed to be greeted the same way.

With the tension broken the afternoon went smoothly on. Ben Talmadge wrote about the event some time later:

"The simple thought that we were about to depart from the man who had led us through a long and bloody war and under whose conduct the glory of Independence had been achieved, and that we would see his face no more in this world seemed to be utterly insupportable."

Indeed it had been a day of overwhelming emotion for the usually reserved Virginia planter. When he left Fraunces Tavern he passed through a Guard of Honor into a huge throng of New Yorkers who filled the narrow streets leading to Whitehall Ferry where a barge was waiting to take Washington to Paulus Hook in New Jersey.

As soon as he was safely aboard the barge the tall figure of the Commander-in-Chief rose and he waved his hat in silent farewell.

He was to return far sooner than he realized.

"First in Peace"

For a little more than three years the Commander-in-Chief became simply Squire George Washington of Mount Vernon, and busied himself with the plantation, suffered an almost continuous stream of visitors including artists eager to paint him, sculptors to cast him in bronze and a goodly number of friends and old companions.

One other project captured much of his time. He became much intrigued with plans to link the Potomac and Ohio rivers and provide a waterway deep into America. As part of this dream he became involved with James Ramsey who had built a rudimentary, but impractical, machine to drive boats by steam power. The project came to nothing.

But his Mount Vernon idyll was not to last.

In May, 1787, largely at the behest of Alexander Hamilton, John Jay and James Madison, a call went out for a Convention to be held in Philadelphia "to render the Constitution of the Federal Government adequate to the exigencies of the Union."

At first Washington resisted the idea but was eventually convinced that some such meeting of the minds must occur if the new nation was to create a durable, and workable union.

There is little doubt that Shay's Whiskey Rebellion did much to convince the Squire that immediate action was necessary.

Washington left Mount Vernon on May 9, 1787, for Philadelphia, where he accepted lodgings at the mansion of Robert Morris where he was to remain until mid-September.

It was, indeed, a remarkable group of men who assembled that Summer in Philadelphia and a remarkable piece of work they accomplished. Among them were:

George Mason, a Virginia neighbor of Washington, who proposed the plan for dual Federal and State sovereignty which is the basis of this nation's government. It was Mason who first suggested the Bill of Rights which later became the first ten Amendments to the Constitution.

Roger Sherman, who broke a long and difficult stalemate by proposing the "Connecticut Compromise" providing that each State have equal representation in the Senate and that a House of Representatives be elected on the basis of population.

INAUGURATION
OF WASHINGTON
APRIL, 1789

Confident men in a strong and jubilant setting inaugurate the first President of the United States—the angel of freedom hovers over, the wisdom of faith is at hand.

James Wilson of Pennsylvania who held out stubbornly, against strong opposition, for the Executive power to be placed in one man.

Senior statesman Benjamin Franklin, then 81 years old, was the soother, the wit who punctured pomposity and the skillful architect of desirable compromises.

It was May 25 before a quorum of the States was on hand, but as soon as the required number was present the first order of business was handled speedily. Washington was unanimously elected President of the Convention.

He presided over the momentous, and often difficult meetings in almost total silence. Only once in four months of deliberation did he make a speech, and that a very brief one. But he did somehow provide the sense of strong purpose and solid authority which this meeting of articulate men and disparate ideas needed very badly.

As a matter of fact the Convention had been called simply to revise the existing Articles of Confederation but what it actually did was create a wholly new form of government. It was a truly monumental accomplishment.

In the end, all but three delegates signed the proposed new Constitution in September 1787. Now came the more difficult job of getting it ratified by the thirteen States.

It was nearing the end of 1788, before Rhode Island, the last State heard from, finally ratified the new "Constitution of the United States of America."

Meantime the old Congress had decided that a new government should be installed on March 4, 1789, and—after much debate—that New York would be its seat.

The Congress also established that on the first Wednesday in January, 1789, each State should name Presidential electors and on February 1, these electors would cast their votes for a President to be inaugurated on the first Wednesday in March, 1789.

Back at Mount Vernon Washington wrote to a friend in Ireland, Edward Newenham:

"We exhibit at present the novel and stimulating spectacle of a whole people deliberating calmly on what form of government will be most conducive to their happiness."

The March 4, meeting of electors did not come off on schedule but eventually the electoral votes were all in and were unanimous in naming George Washington of Virginia as President of the United States ·of America.

On April 14, Irish-born Charles Thomson, who had been Secretary to the Continental Congress since 1774, arrived at Mount Vernon with the word—formally stated in a letter from John Langdon of New Hampshire, President pro-tem of the Senate.

Two days later George Washington left Mount Vernon by coach with Thomson and David Humphrey, a wartime aide, and set out for New York.

Nothing could have prepared Washington for the tumultuous trip that lay ahead of him. The country had never seen anything like it—nor would it again for a long time.

Each village and town and city between Mount Vernon and New York turned out *en masse*—greeting the new President with parades, fireworks, guards of honor, folk dancing, ceremonial arches, endless speeches and resolutions of faith and fervor.

At Trenton children strewed flowers in his path while a chorus of young women led the cheering procession.

From Paulus Hook a garlanded barge ferried Washington and his party across the bay to New York—and another rousing welcome and public festivities which lasted a full week.

On April 30, 1789, on the handsome pillared balcony of Federal Hall at Broad and Wall streets, overlooking a crowd that filled the streets as far as the eye

could see, George Washington was inaugurated President of the United States.

John Adams, Vice President, was at Washington's right.

Robert R. Livingston, Chancellor of New York State, at Washington's left, administered the oath of office while Samuel Otis, Secretary of the Senate, held the Bible on a velvet cushion.

Alexander Hamilton was there, and Henry Knox, Arthur St. Clair, Baron von Steuben and several other dignitaries and old friends.

When the oath had been administered Chancellor Livingston announced:

"It is done! Long live George Washington, President of the United States of America!"

The thousands in the thronged streets responded as one roaring voice of approval—the exultant sound of a free people who had made a successful war and would proceed with the world's most successful Revolution.

It Was Everybody's War— Even the Horses

When it comes to heroic figures in the American War for Independence any American has his free choice of ethnic groups, nationalities or religions—they were all there.

General John Sullivan and Navy Captain John Barry, for example, were both Irish Catholics, so was John Carroll, signer of the Declaration. John Paul Jones was a Scot. Pulaski and Kosciusko were Poles. Barons von Steuben, deWedtke were Germans. Lafayette, de Coudray, Rochambeau, de Grasse and many others were French.

With the exception of the Regular French Army and Navy, who were serving as Allies, these, and other Europeans, flocked to the American cause because they were swept up by the fresh winds of freedom and liberty promised by America's Declaration of 1776.

Nathanael Greene and Betsy Ross were Quakers. Lt.

Colonel Frank Isaacs of Washington's staff and Major Benjamin Nones of Lafayette's staff were Jewish, as were Colonel David Franks and Haym Solomon who gave his fortune of nearly $1-million to the American cause and died broke.

The American Indians, long associated with the enemy, were not all on that side of the conflict. Many of the Mohawks of upper New York served as scouts for Gates and Arnold. Several Cherokees served with Wayne on his Western campaign.

American Blacks were hip-high in the war from the very beginning. Crispus Attucks, a Black, is memorialized as the first American to be killed by British bullets in the Boston Massacre of 1770.

Salem Poor, Barzilli Lewis and Peter Salem, all Black men, fought in the stirring American action at Breed's Hill.

Salem Poor was decorated for his valor in that battle.

Maryland and Rhode Island each had Black Regiments which fought in several major actions including the joint American-French attack on Newport, Rhode Island.

Prince Whipple, who was a slave of Captain Wm. Whipple of New Hampshire when the war started, was freed by the Captain because Prince made his views very clear:

"You are going to fight for your freedom" he told the Captain, "but I have none to fight for."

Prince Whipple did fight, he was an oarsman in the Durham boat which carried Washington across the Delaware for his attack on Trenton.

About 6,000 Blacks served as soldiers in the War of Independence. The normal battalion of Continental troops averaged about 50 to 60 Black troops.

The success of the war brought about a substantial increase in the number of free Blacks in the country. By 1790, there were about 60,000 free Blacks. The only direct comparison available is in Virginia where, in 1782, there were 2,800 free Blacks. By 1790, they numbered nearly 13,000.

The role of women in the Revolution has been much discussed in recent years, as has the singular story of Deborah Sampson.

Deborah was bound and determined—in more ways than one—to fight in the war. So she disguised herself as a man, cut her hair, bound her breasts, borrowed some old clothes and enlisted as "Timothy Thayer" and collected her $100 bounty.

What gave "Tim Thayer" away fairly early was his inability to drink without giggling. Her giggles found Deborah out and she was pushed out of the Army.

Nothing daunted she tried it again as Private Robert Shutleff of the 4th Massachusetts Regiment of Foot—in other words as a "dog-face infantryman." This time she stayed away from taverns and served for more than two years, finally as an orderly to General John Paterson.

Deborah was finally unmasked by illness. When a Doctor demanded a much closer listen to her heartbeat Deborah was through as an infantryman.

"Why, this is truly theatrical," was Gen. Paterson's undying remark when his orderly was discovered to be a 24-year-old young lady of some latent charm.

A life size statue of Mrs. Karen Happuch Turner of Maryland, stands to this day at Guilford Court House, North Carolina. It celebrates Mrs. Turner's ride from Maryland to North Carolina to nurse a son who was wounded with General Greene's army in the battle of Guilford Court House.

This indomitable lady rode more than 300 miles. Paul Revere rode sixteen miles.

Perhaps the most important result of relatively recent scholarship on the role of women in the American Revolution is the strong evidence that most of the women who followed the American armies were, indeed, wives of the soldiers and not the shrill "camp followers" of earlier lore. Molly Pitcher has come to be the symbol of them all.

Horses—all kinds of horses—were of critical importance to the armies of the War of Independence. They served as beasts of burden, as transportation for officers and men and as a strike force in Cavalry units. Forage for the animals was often a serious problem. (One of the first hints of British disaster at Yorktown was the killing of horses as forage ran out during the siege.)

One minor mystery of the time is the apparent failure of the American army—full of superb horsemen—to use Cavalry more consistently as the "eyes of the army." For example:

As early as the Battle of Long Island and the battle at the Brandywine and in several other major engagements, the British used wide flanking tactics—whole armies would move in a wide circle around the "blind side" of American troops in battle position, strike them from the rear and then roll up the whole flank.

Light Cavalry units posted as scouting parties three to five miles on either side of the American armies could have spotted these enemy movements early and accurately.

Somehow the American Commanders, and for that matter the British and French of that era, seemed to use horses only as personal transportation or as fighting units—the traditional hell-for-leather Cavalrymen riding down on troops and cutting them up with saber attacks. In short, using the horse as a kind of "live light tank."

The use of Cavalry as "eyes of the army" was brought to perfection in the American Civil War—and probably most superbly by the Confederate forces.

Earl Shenk Miers, in a charming essay called "Horse Sense" published in 1970, solves one of the intriguing puzzles of the debacle of General Horatio Gates at the Battle of Camden.

Miers traces the appearance in America of both the Quarter horse and the Thoroughbred as race horses, notably in the South.

"Among the early horses that rose to fame in Colonial America was 'Fearnought,' a descendant of the Darley Arabian. This handsome Thoroughbred, standing over 15 hands, bred some of the finest race horses in Virginia. Moreover he played a unique role in the Revolution.

"From the outset Washington had been disappointed in the decision of Congress to place Horatio Gates in command in the South. Behind his back the frequently befuddled Gates was called 'the Old Grandmother.' He accepted far more credit than he deserved for the smashing victory at Saratoga . . .

"Gates' first battle against the British under Lord Cornwallis in South Carolina came at Camden in mid-August, 1780. It was to be Gates' last engagement for his troops were no match for the Redcoats. The battle turned into a wild scramble of retreat and the Americans did not stand on their manner of going. Nor did Gates. In three days, astride the famous 'Fearnought' he covered 180 miles from Camden to Hillsboro!"

Thus the mystery of how Gates fled so far so fast is made clear. He "conscripted" the fastest horse in the South and headed for the barn.

MEN, WOMEN AND HORSES

War is over. The promise of peace and plenty and freedom for all is at hand. Now for the great and glorious, never-ending Revolution.

A Note About the Collaborators

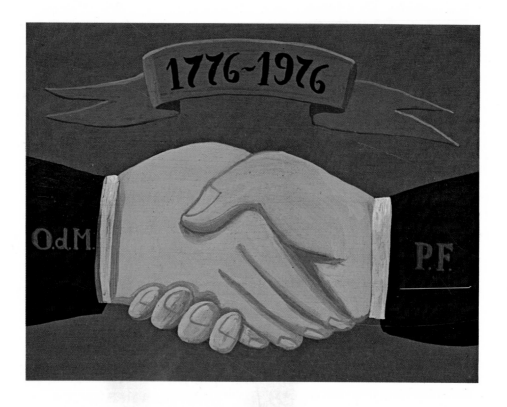

This book was designed by Henry Wolf
L.U.R.

Paul Foley, who wrote the text, commissioned Oscar de Mejo in 1973 to do a series of paintings of the American Revolution.

Mr. De Mejo is an American of Italian birth who began his art career in Hollywood. His first exhibition was in Taylor Galleries in Beverly Hills in 1949. He has since been widely shown in the United States and in Europe, including the major Biennale of Art Naif at Lugano, Switzerland in 1972.

He and his unique work are in much of the contemporary literature on Naive Art, notably Oto Bihalji-Merin's major work "Masters of Naif Art," McGraw-Hill, 1972, and Selden Rodman's "The Eye of Man," New York, 1955, and several others.

Naive, or Primitive, art is an ideal medium for the fable-like stories of ancient battles and the storied people and places of history. Most of the paintings in this volume were on exhibit at Jamestown, Virginia and The College of William and Mary at Williamsburg, Virginia during 1975.

Paul Foley has worked at some form of professional writing for most of his career. After earning a degree in Journalism at the University of Notre Dame, he worked as a daily newspaper reporter in Chicago and Detroit. He was a foreign editor in Turkey for OWI during World War II and has been a writer of advertising for most of the past thirty years. For at least twenty years he has been a Revolutionary War "buff." He has also done several magazine pieces and two one-act plays. Mr. Foley is Chairman of The Interpublic Group of Companies, Inc., which sponsored Mr. De Mejo's paintings.